RONALD SEARLE IN *LE MONDE*

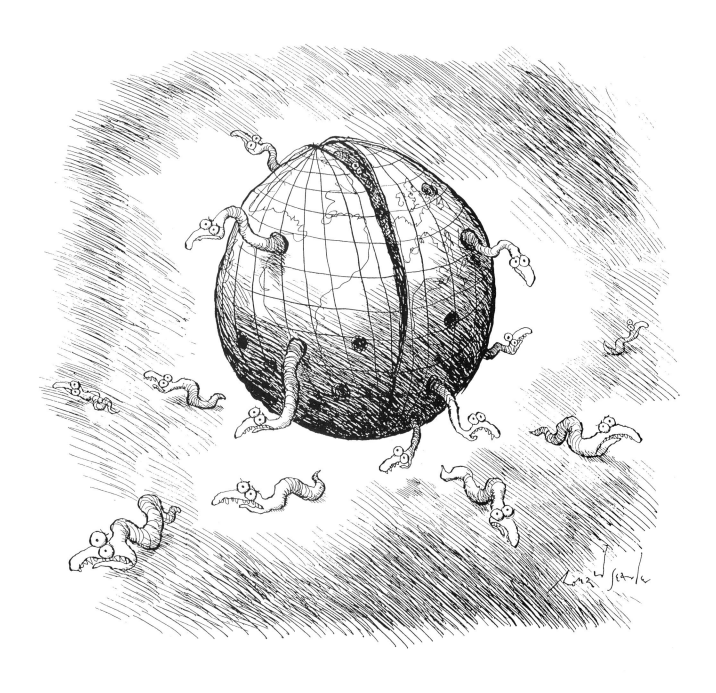

Fin de siècle

RONALD SEARLE
IN *LE MONDE*

Ronald Searle

THE UNIVERSITY OF CHICAGO PRESS ● CHICAGO AND LONDON

RONALD SEARLE is a graphic artist, cartoonist, animator, and film designer. He is the author of dozens of books, most recently *The Terror of St. Trinian's and Other Drawings*. He has had one-man shows in New York, Philadelphia, San Francisco, and all over Europe, and his work is also found in the permanent collections of museums in London, New York, Paris, and Berlin, among others.

The University of Chicago Press, Chicago 60637

The University of Chicago Press, Ltd., London

Printed in the United States of America

11 10 09 08 07 06 05 04 03 02 1 2 3 4 5

ISBN: 0-226-74408-6 (cloth)

Library of Congress Cataloging-in-Publication Data

Searle, Ronald, 1920–

 Ronald Searle in Le Monde / Ronald Searle.

 p. cm.

 ISBN 0-226-74408-6

 1. Searle, Ronald, 1920– 2. World politics—1989– —Caricatures

and cartoons. 3. French wit and humor, Pictorial. 4. Editorial

cartoons—France. I. Monde. II. Title.

D860 .S4 2002

741.5'942—dc21

 2001007375

This book is printed on acid-free paper.

CONTENTS

Preface xi

POLITICS

MONEY

SOCIETY GAMES

SOME ANGELS

EPILOGUE

"QUI ÊTES VOUS, RONALD SEARLE?"

In my creaking eighties, after more than sixty years of publicly grappling with the peculiar nuances of graphic humor, I realize that, nevertheless, I am probably an unknown quantity to many of those who might encounter this book. So, for anyone interested in finding out who, or what, may be lurking behind the images on the following pages, a modest personal résumé follows.

The French have a neat way of tackling this situation on TV. The interviewer tosses the ball directly into the lap of the victim and poses the question *"Qui êtes vous?"* (Who are you?). Then, slumping back into his, or her, interrogation chair, lets the sweating unfortunate do the work. As the story unfolds, now is the time to reach for your box of tissues …

I was the first of two children born to a modest East-Anglian working-class family. Arbitrarily, fate stuck a pin into the map of England so that geographically and artistically, I was given an unexpectedly privileged start in life. Instead of being born in the bleak back-street of some grim industrial city, I arrived in the ancient university and agricultural town of Cambridge on the third of March 1920, in lodgings on the busy road to Newmarket racecourse.

During the First World War my mother, a country girl from Wiltshire in the south of England, had met and married my father, then a young professional soldier. At the time of my birth my father had been invalided out of the army. He was still recovering from the effects of poison gas and had returned, hardened and disillusioned, to his family roots in Cambridge. In a depressed postwar England he was now a twenty-three-year-old luggage porter on the local railway station, with a family to keep.

Postwar Cambridge, then a sleepy, underprivileged market town, had been dominated since the thirteenth century by its powerful, royally patronized university. In contrast with the modest means of the town, the university, a panorama of architectural splendor, boasted a number of richly endowed museums, and its seventeen colleges contained matchless libraries full of treasures.

Although they belonged to the university, the museums were open to the public and, throughout my childhood, my younger sister and I spent all our spare time soaking up the splendors and curiosities of these esoteric collections. Fascinated, we wandered among terrifying, ancient, bottled anatomical specimens and ethnographic rarities from university expeditions to the darker corners of the earth, such as shrunken human heads, monstrous stuffed beasts, as well as unspeakable objects from the

blackest of secret rituals. This was perhaps the cradle of the darker side of my sense of humor. Less gruesomely, there was also a rather intimidating museum of towering, dusty casts of classical Greek and Roman sculpture.

Above all there was the Fitzwilliam—a modestly sized museum of incredible richness with its ancient Egyptian sarcophagi, medieval armor, a world-renowned collection of Renaissance paintings, the remarkable assemblage of works by William Blake, as well as an impressive cabinet filled with brilliant watercolors by Turner. To us adolescents it was a revelation. Most unusually for a "serious" museum there was also a small room of contemporary caricatures, mainly devoted to Max Beerbohm, and it was here that my fascination with graphic humor was born and, soon after leaving school at the age of fifteen, I began contributing a primitive weekly cartoon to the local newspaper.

In addition to working—first as a parcel wrapper, then as a clerk—in a local emporium, I began to attend evening classes at the Cambridge School of Art. In 1938, after three years hard work, I fulfilled a dream. I was awarded a full-time art scholarship. But this pleasure was short-lived. By early 1939 the possibility of war became a reality and, along with my school friends, I volunteered to join the army reserve.

A few months later World War II was declared and—with a little album of the work of one of my heroes, the German satirist George Grosz, stuffed into the pocket of my uniform—I became a reluctant soldier for the next seven years. After an interminable spell of training and work on the art of camouflage for anywhere but the jungle, our brigade was shipped to the Far East in the winter of 1941. There we were to encounter the Japanese, who were now advancing down the Malayan peninsula. In February 1942, at the age of twenty-one, after several weeks of chaotic fighting, I was captured along with my friends. We remained prisoners of the Japanese for almost four years, spending a nightmarish time in the jungle of Thailand working on the so-called Death Railway and, among other things, on the construction of the notorious bridge on the river Kwai. Not surprisingly this baptism of cruelty and brutality by man toward man was to mark me and my work from then on.

Ultimately liberated from Changi prison in Singapore at the capitulation of Japan in 1945, skeletal, unwell, and penniless, I returned to an England that had totally changed. In 1946 I moved to London and set about earning my living as a freelance artist. Thanks to my bizarre, black, ex-prison humor and my by now fluent pen, I swiftly became noticed as being something different in the world of graphics. Soon I was not only working for European publications but was invited to become special features artist for such exotic magazines as *Holiday* and *Life* as well as eventually selling covers to the *New Yorker*. As a result of a solid academic training, my artistic range was almost unlimited and I was able to work in an extraordinary variety of fields: film animation for Hollywood, commemorative medal sculpting for the French Mint, book publishing in England, and, for a long time, I was the theatre caricaturist for *Punch*.

In 1961 I had left London to live in Paris, where I had met my future wife, Monica, a theatre and ballet designer. For the next few years, together, we traveled ceaselessly on international reportage, mostly for and in America. Then, reluctantly, in 1975, we had to leave Paris and resettle into a different life in the mountains of Provence.

The vast store of impressions and opinions that I had built up after years of traveling to record the vagaries of human na-

ture was now to serve me well. In 1995, I was offered the opportunity of contributing editorial drawings to the French national newspaper *Le Monde*.

For this aspect of graphic satire, erudition is not the most vital requirement. What is needed most is gut reaction to the *bêtises* of the human race. As man has yet to escape from the barbarian mentality still simmering beneath the thinnest of cultural veneers, subject matter is, unfortunately, always richly present. In an age when disasters, massacres, executions, and other miscellany of man's enlightened imagination are now mere TV news items to the vast majority of the public, it comes as no surprise that it is so difficult to reach a zone of human sensitivity beyond the TV screen.

After years of scratching away with a sharpish pen and countless buckets of ink, mostly in the well-ploughed field of light-hearted humor, it was fascinating to be offered an opportunity to change direction. The possibility of commenting on current events and, in particular, on those situations involving man's fatal propensity for self-destruction, is something that does not arise every day. When the offer to do precisely that came from a newspaper of such repute, I was halted in my tracks.

It is difficult to assess whether or not, in these days of computer-educated visual barbarians, satirical graphics can have the slightest impact on public opinion. On the whole I am pessimistic and fear that I am exercising a moribund art. But I push on hopefully—and will do so for as long as *Le Monde* will go on publishing the efforts.

For those who are not familiar with the nuances of the French press, *Le Monde* is a liberally minded afternoon newspaper, published from Paris since 1944 and now the most read and probably the most influential national daily in the country. For its fiftieth anniversary the paper was entirely rethought and redesigned. Among the innovations, in a paper noted for pages unsullied by any image, an exceptional amount of space was reserved for illustration and graphic comment. Although drawings and photographs are now tastefully spread throughout the paper, a four-column area on the main editorial page is the most desirable and fought over space. It was here, between 1995 and 2001, that the drawings appeared from which a selection was made for this book.

Drawings for this space are not solicited. There is no editorial pressure or guidance. It is left to the artist to seek and express his point of view. The editor either accepts it or returns the drawing. It is a tough exercise and a challenging one. Hopefully the effort involved remains hidden from the reader—but not the point of view.

Ronald Searle

January 2002

POLITICS

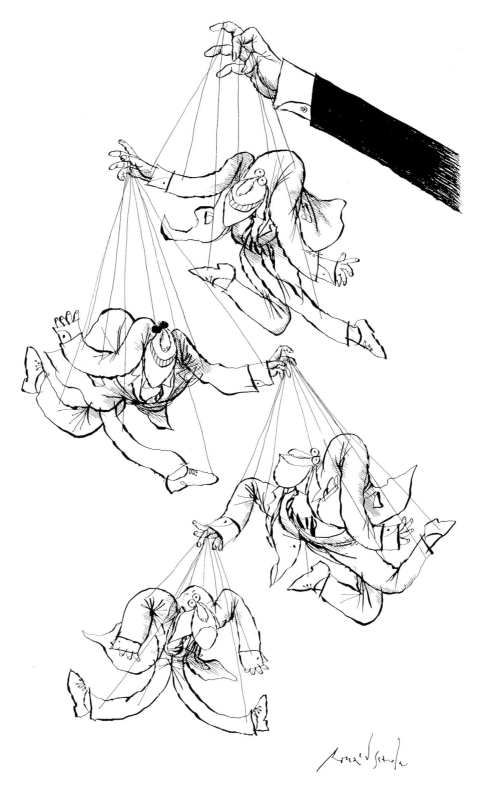

Who's pulling the strings?

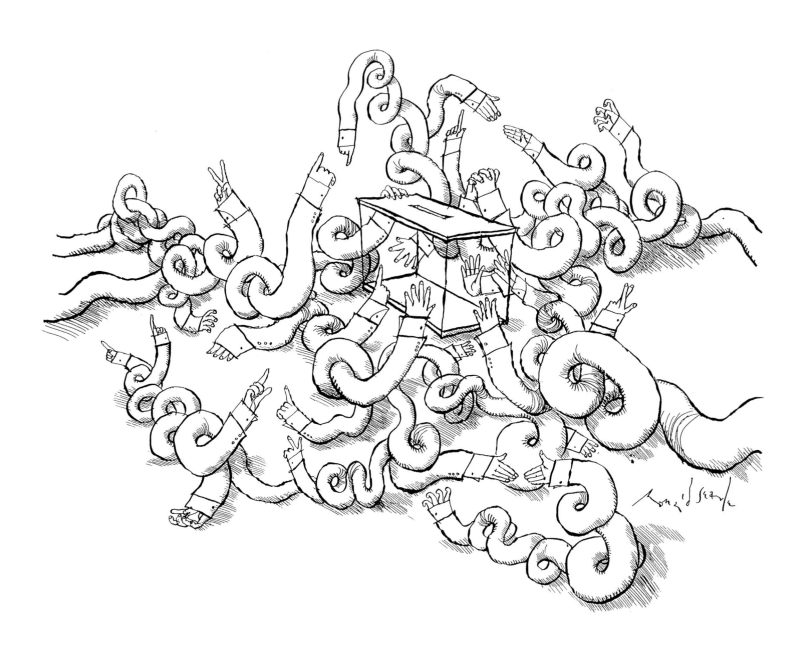

Unraveling the election

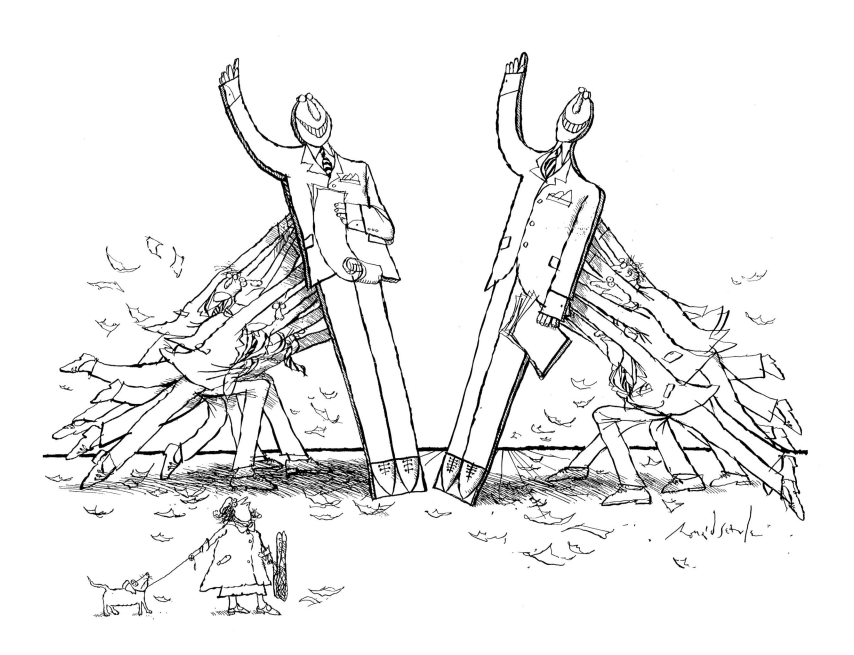

Electoral battle of the Titans

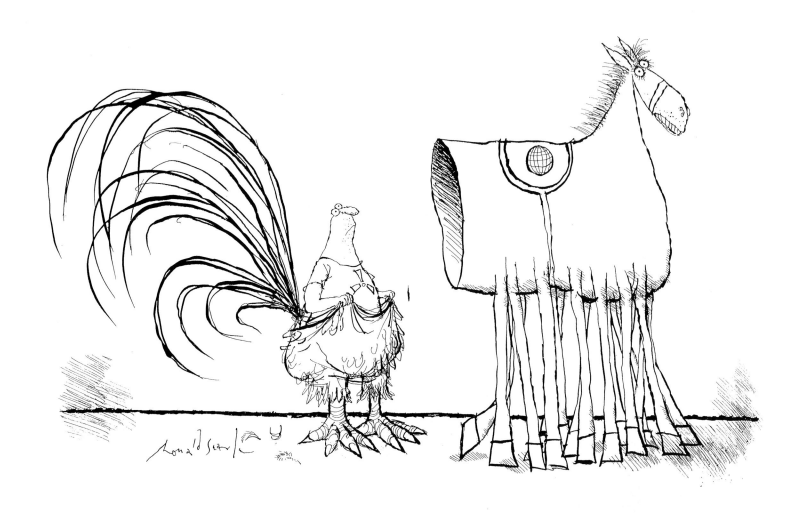

Faux pas

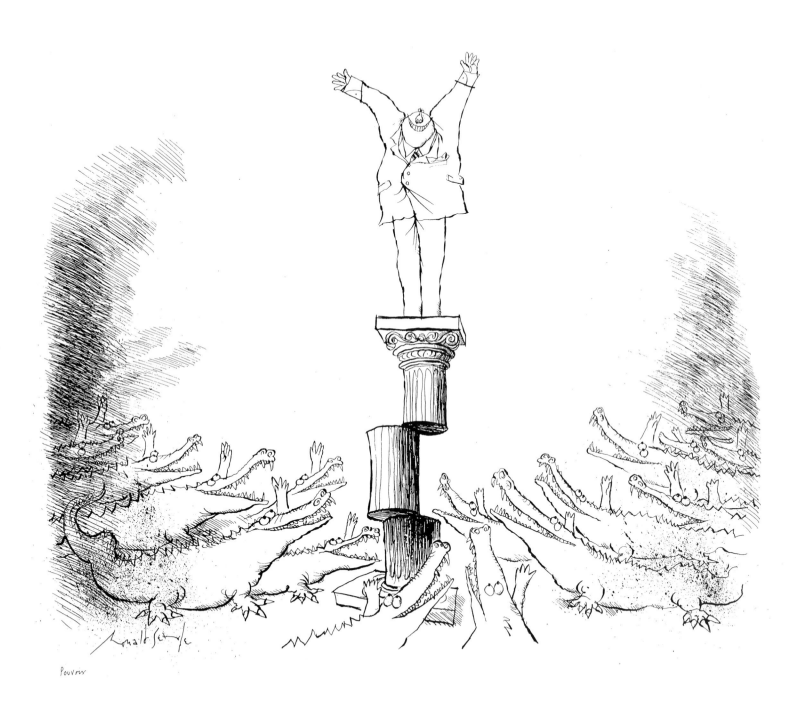

Pouvoir

Power

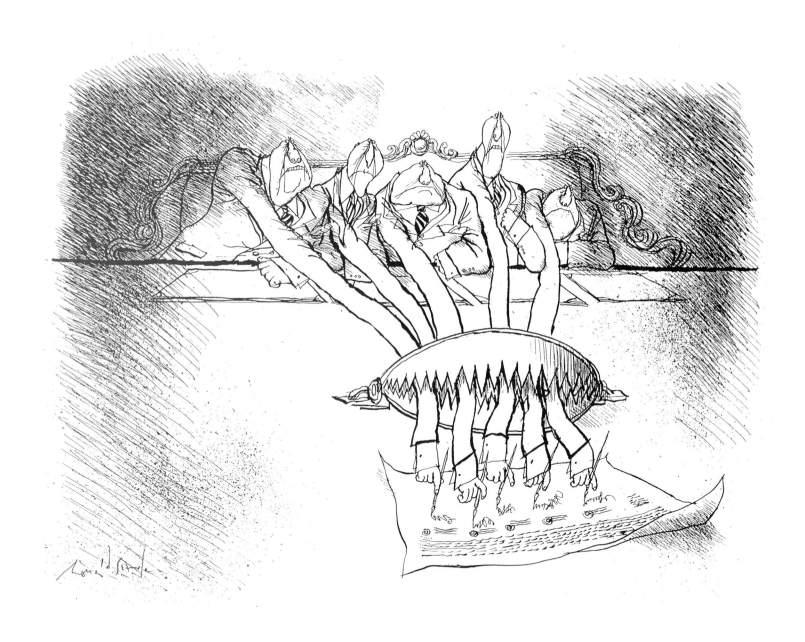

The pact

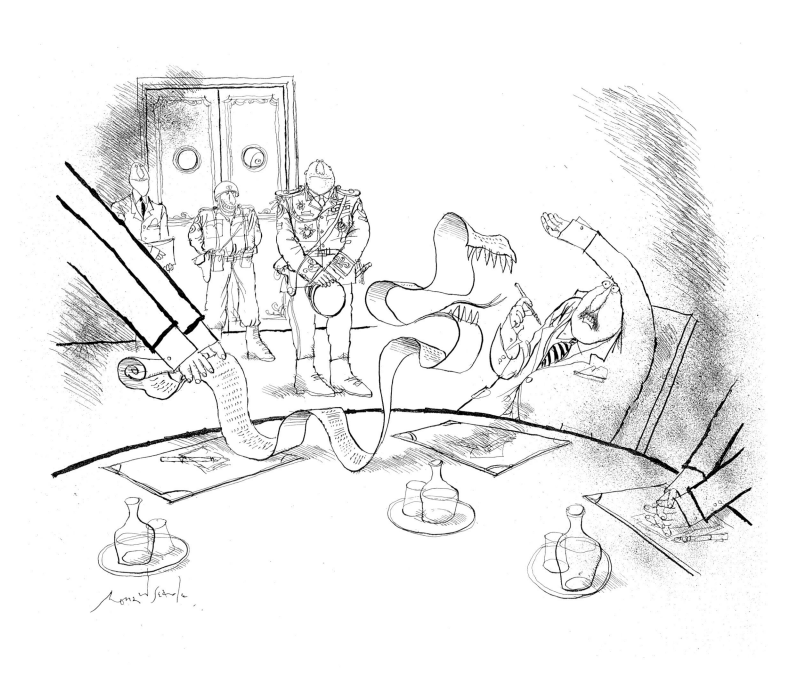

The pact

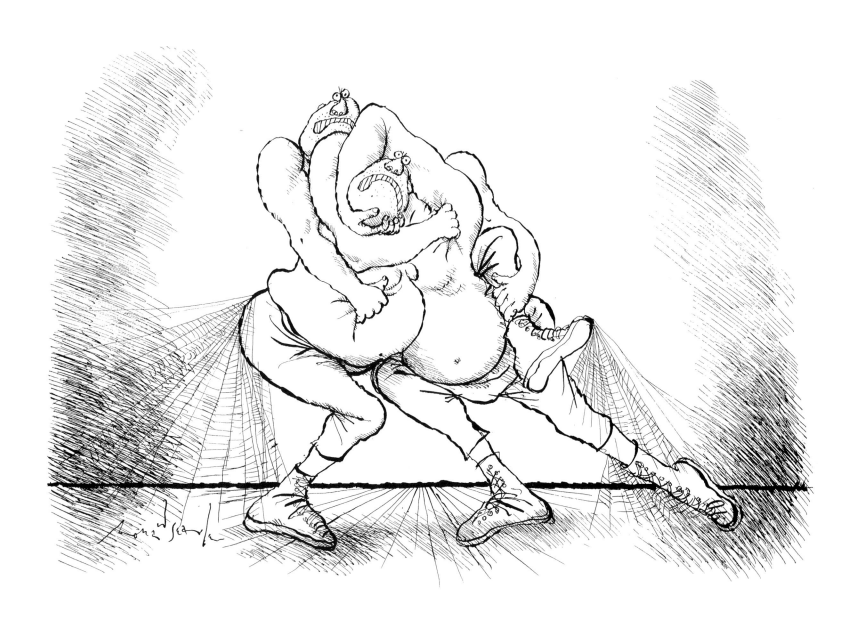

Stalemate

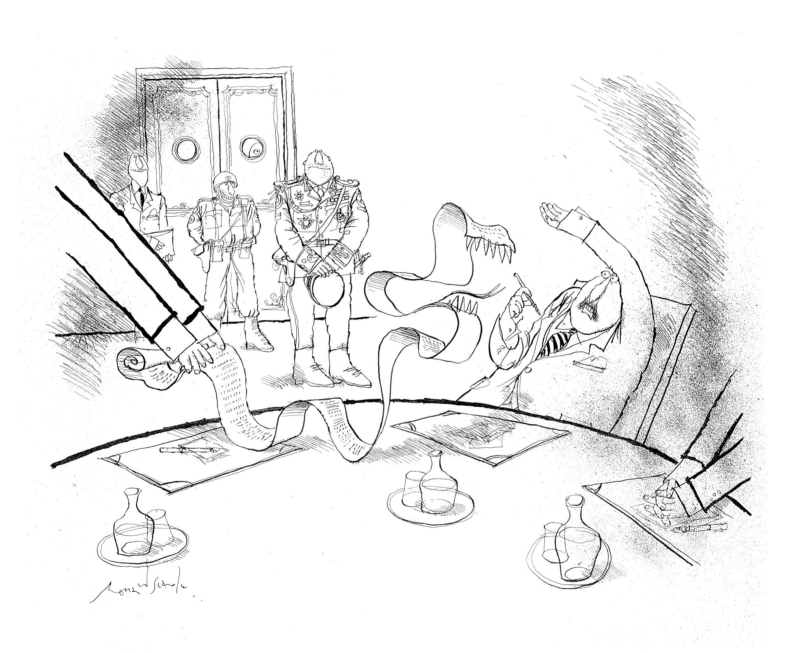

The pact

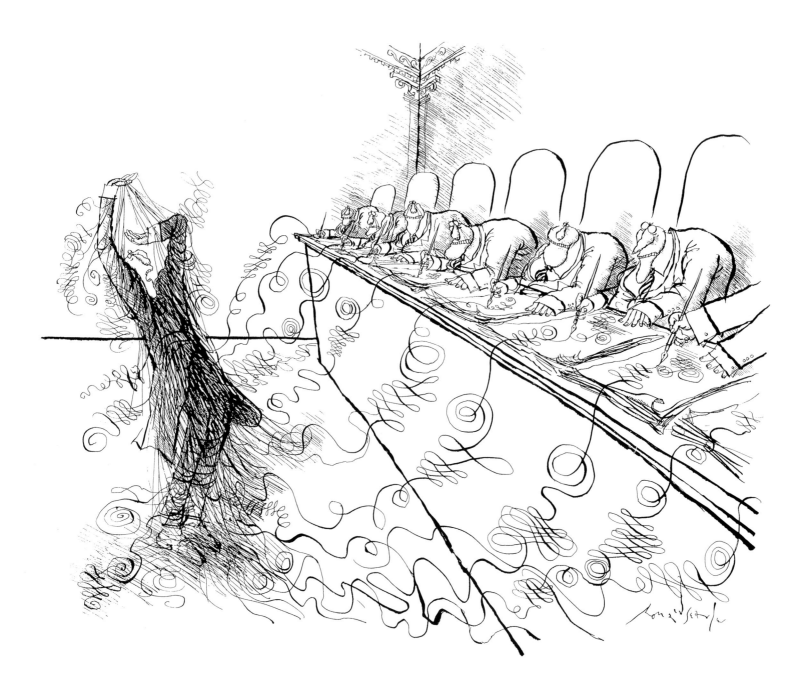

The negotiators

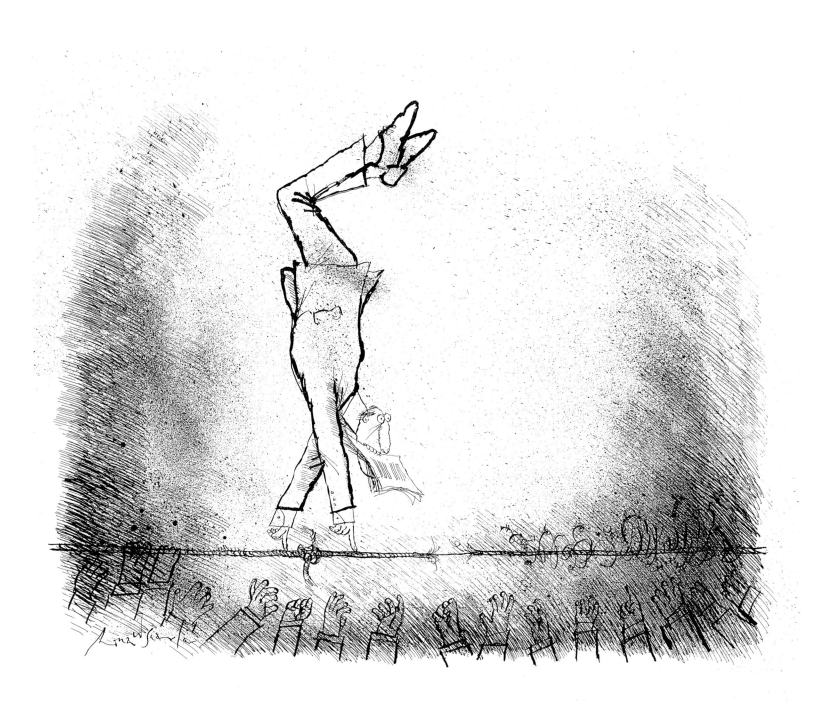

The negotiator

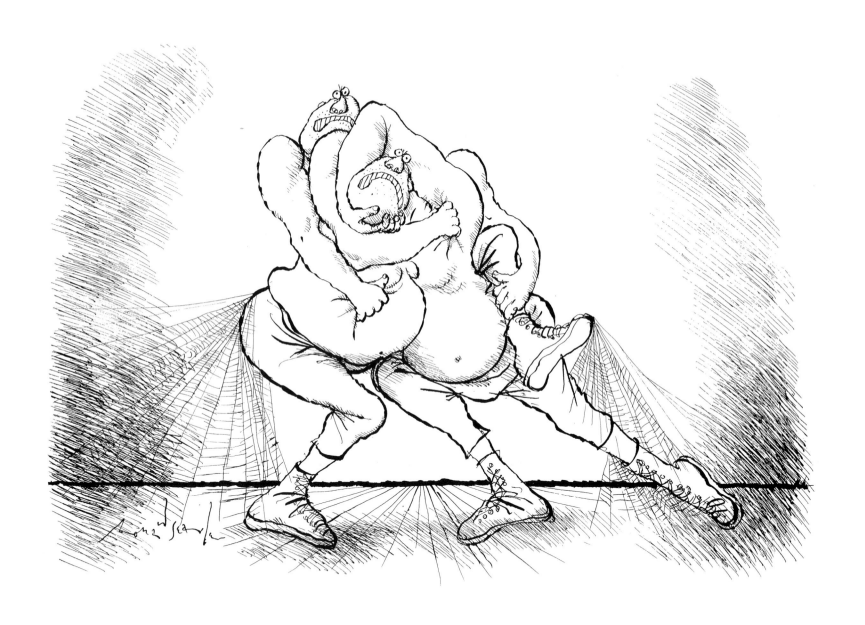

Stalemate

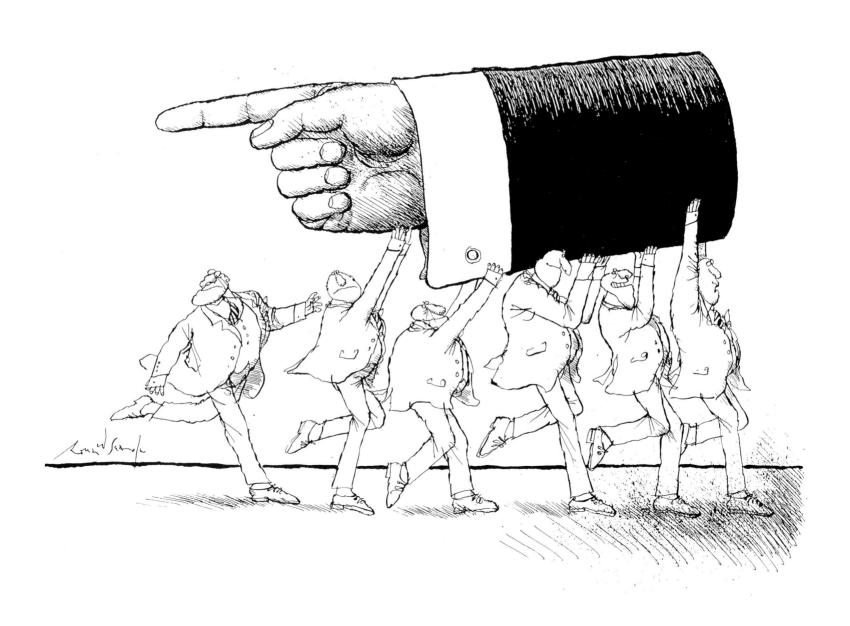

Against the tide

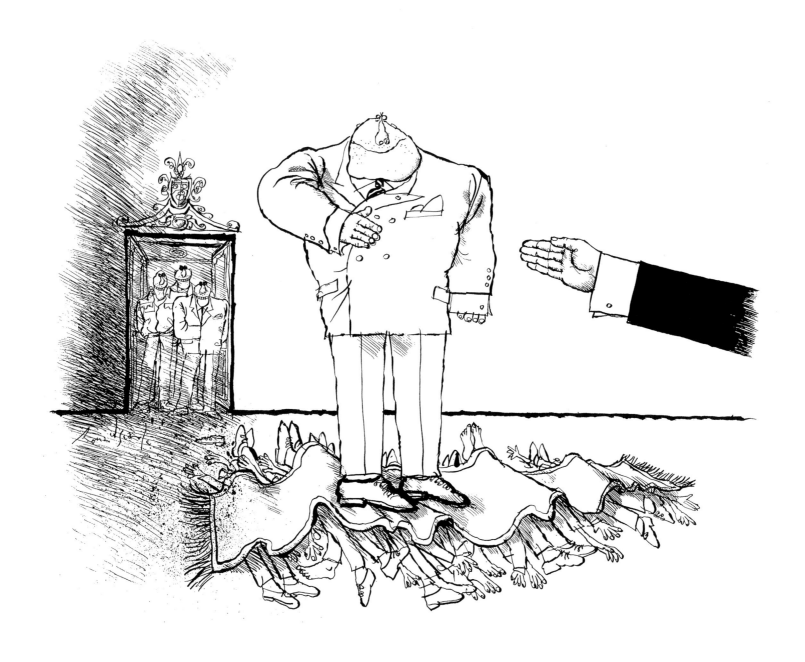

Diplomacy

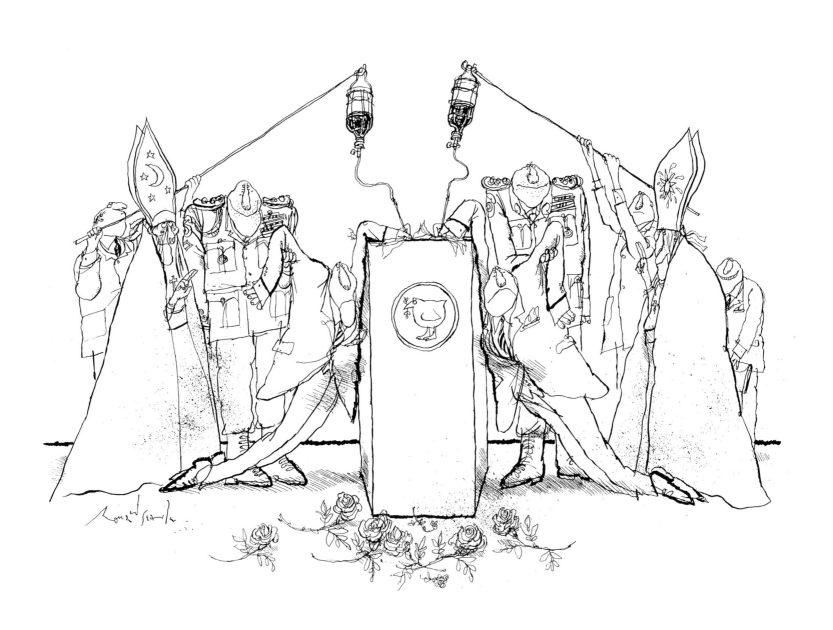

An honorable peace

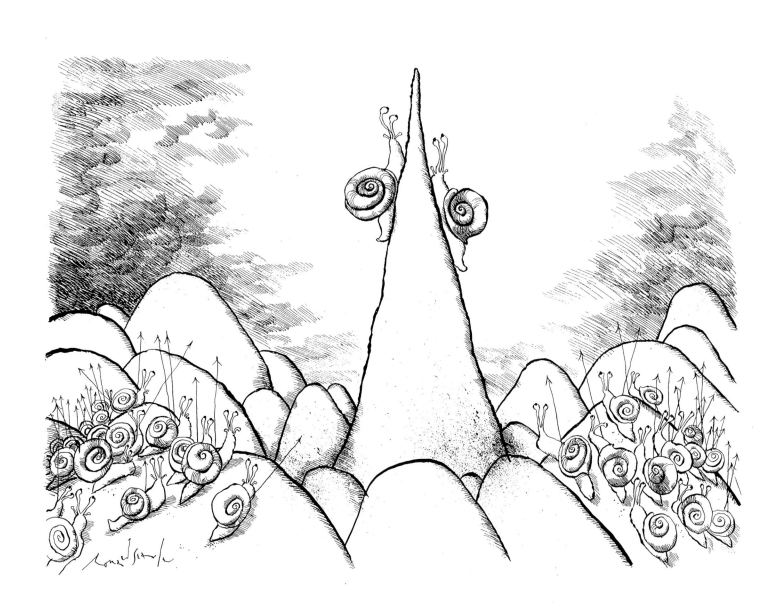

Summit meeting

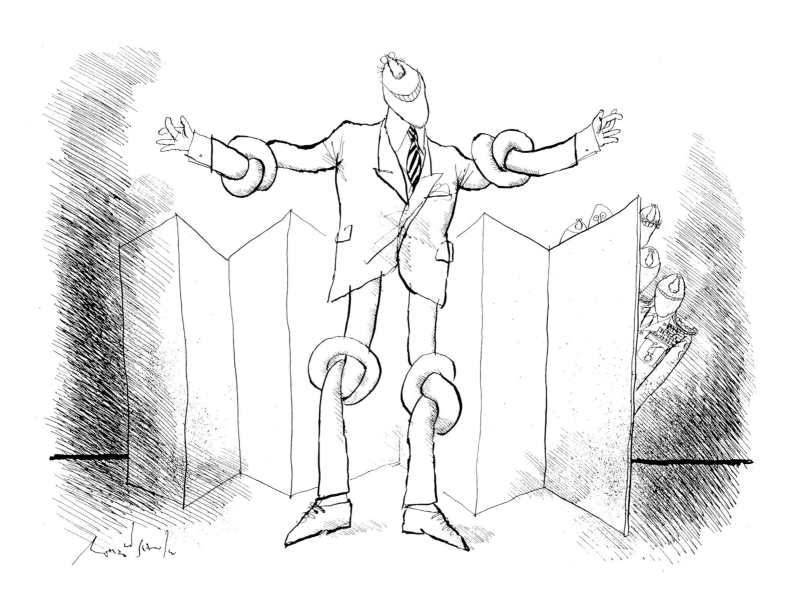

Diplomatic clarification

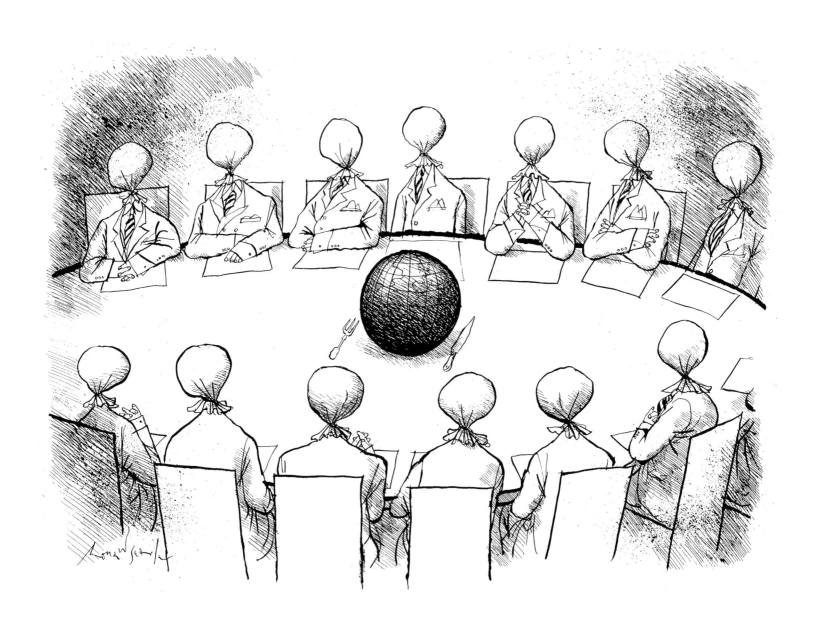

Dialogue of the deaf

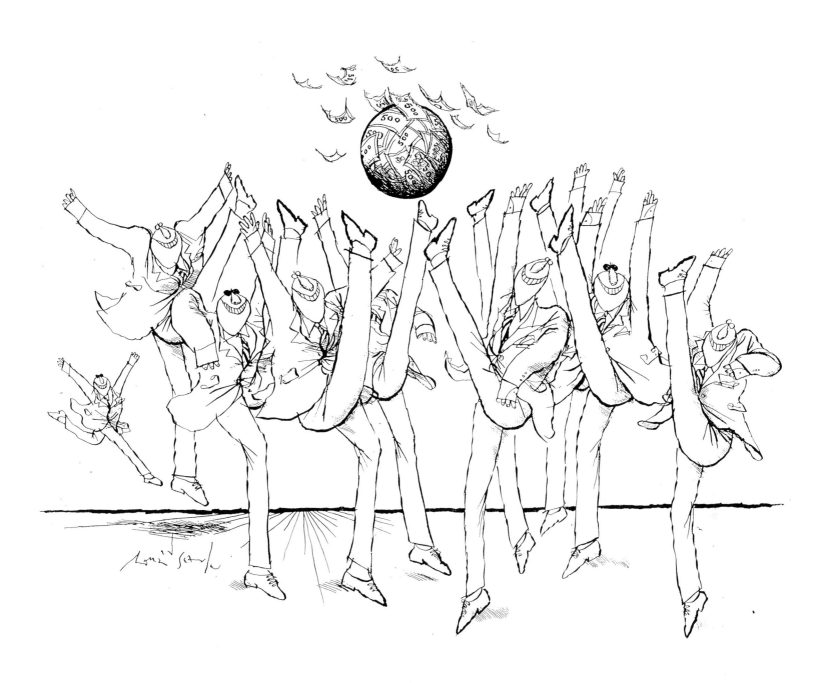

Having a ball

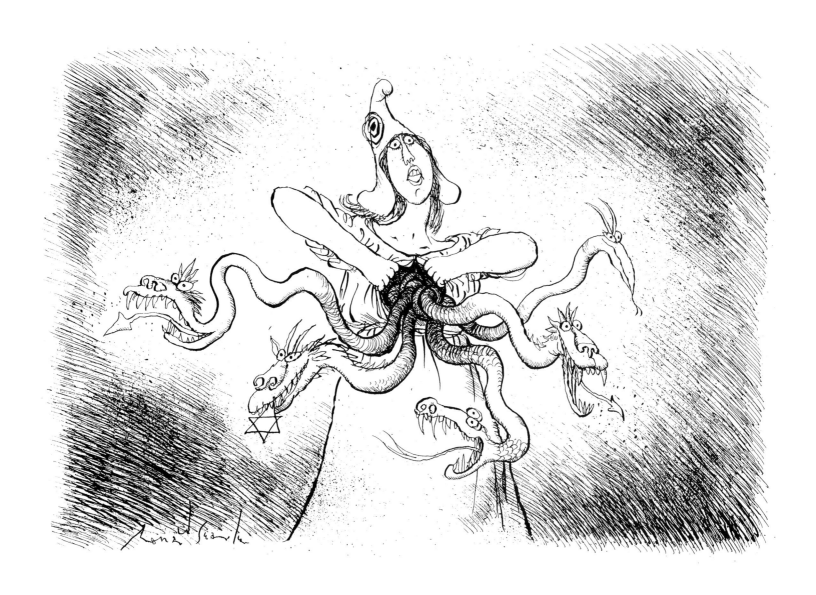

20

Pandora

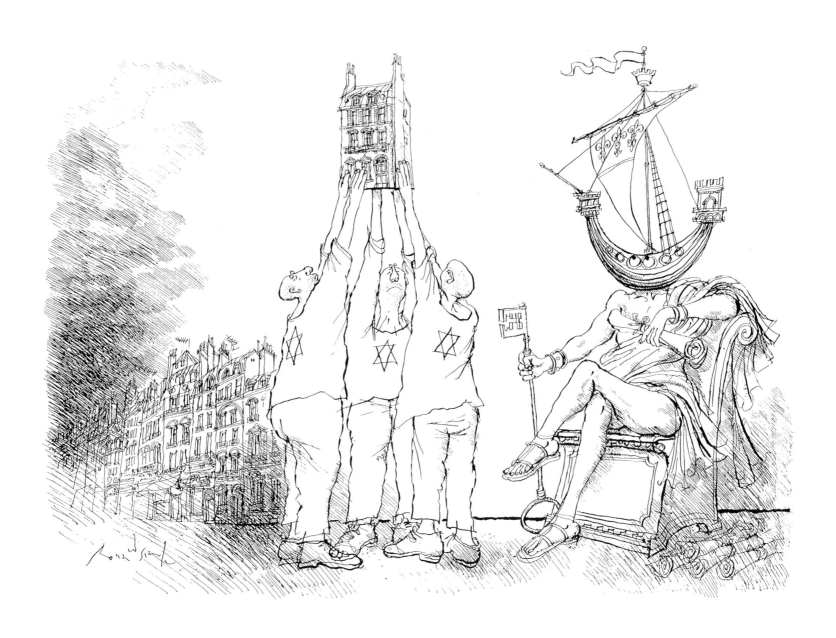

The judgment of Paris

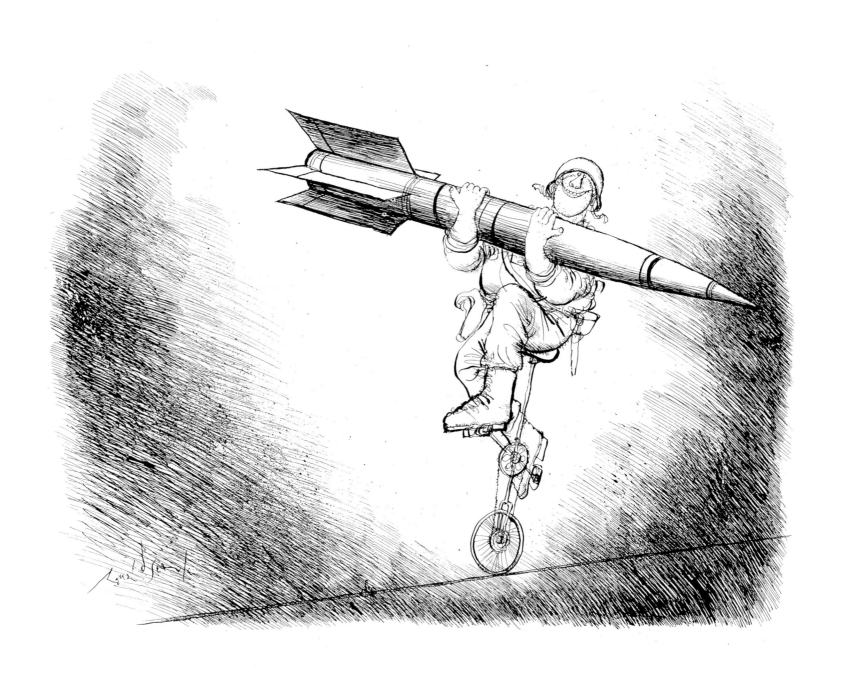

Balance of power

EUROPE

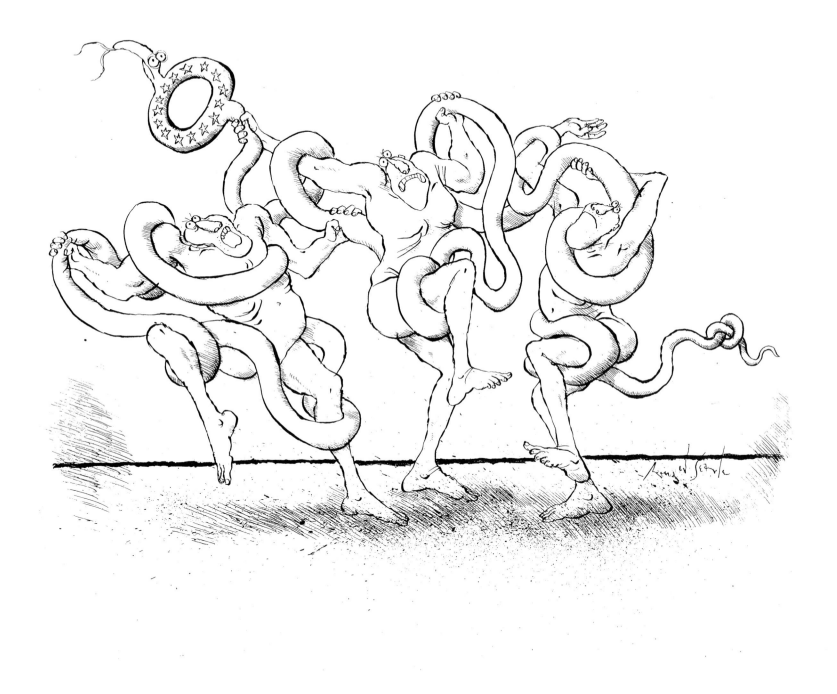

Eurodance

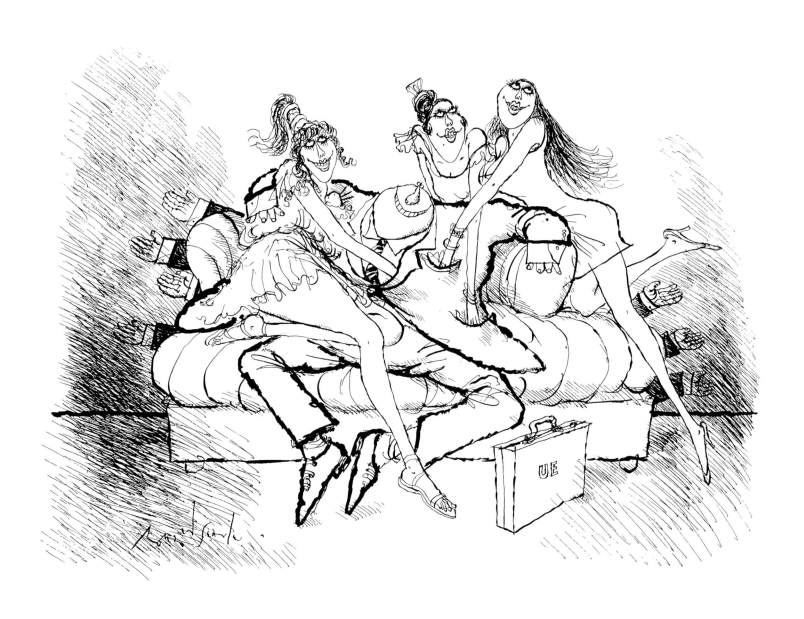

Monetary union

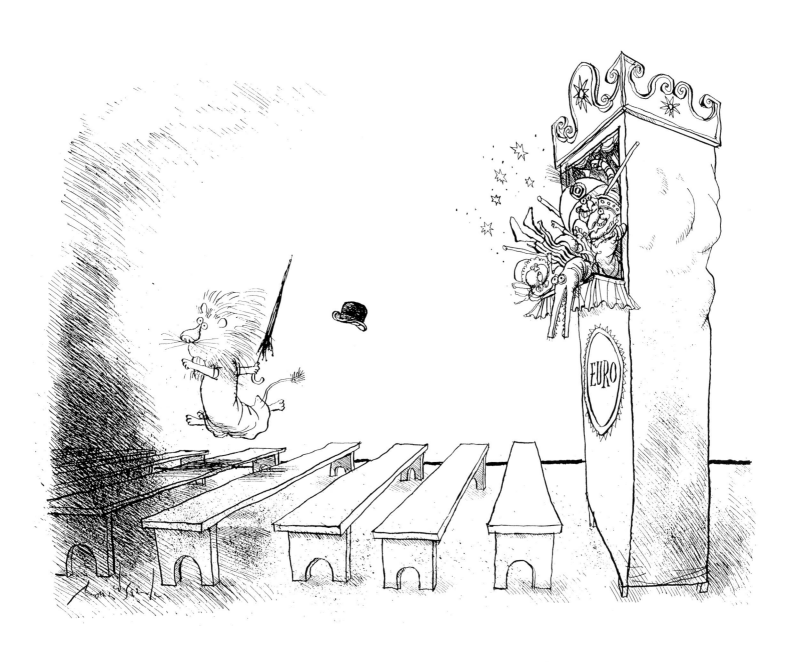

Britain resists the Euro

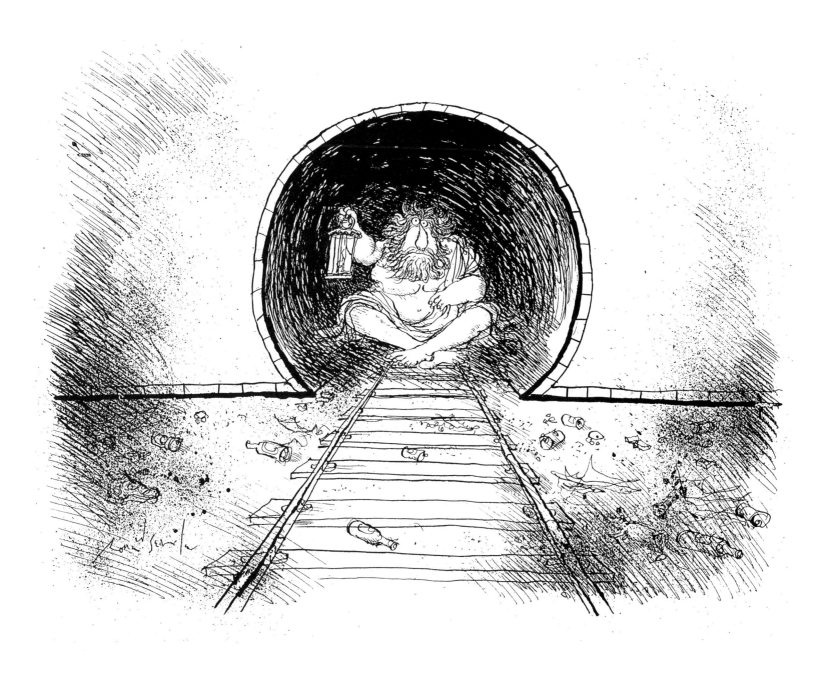

Eurocynic Britannica

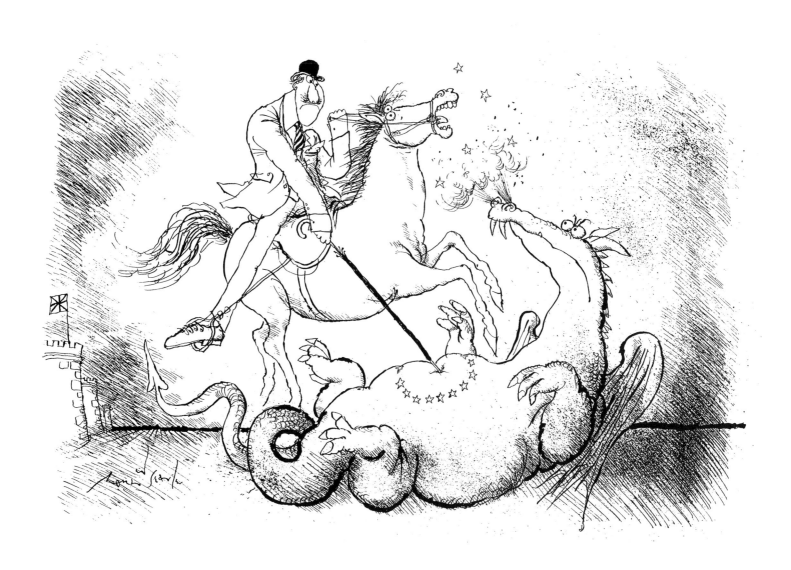

Euroskeptic Britannica

AFRICA

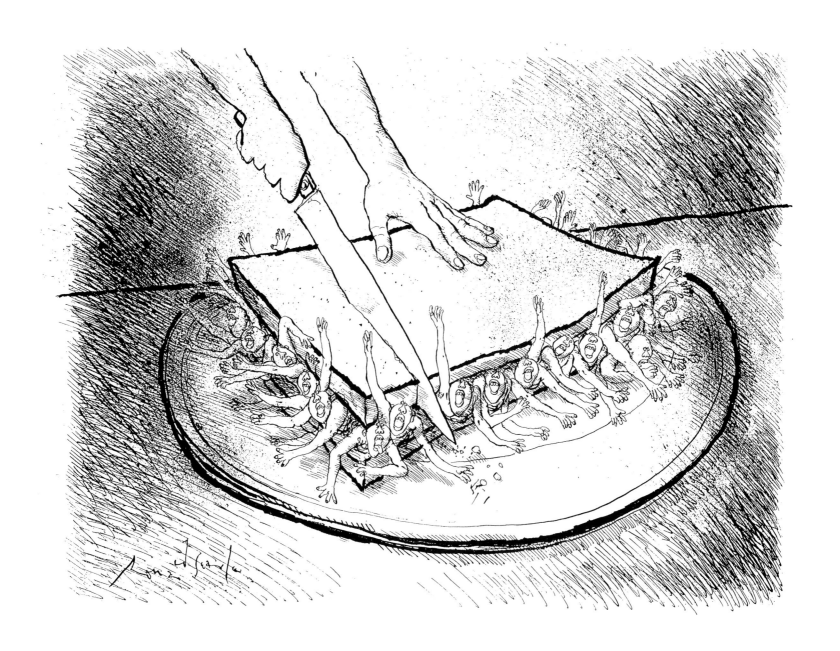

Sandwiched

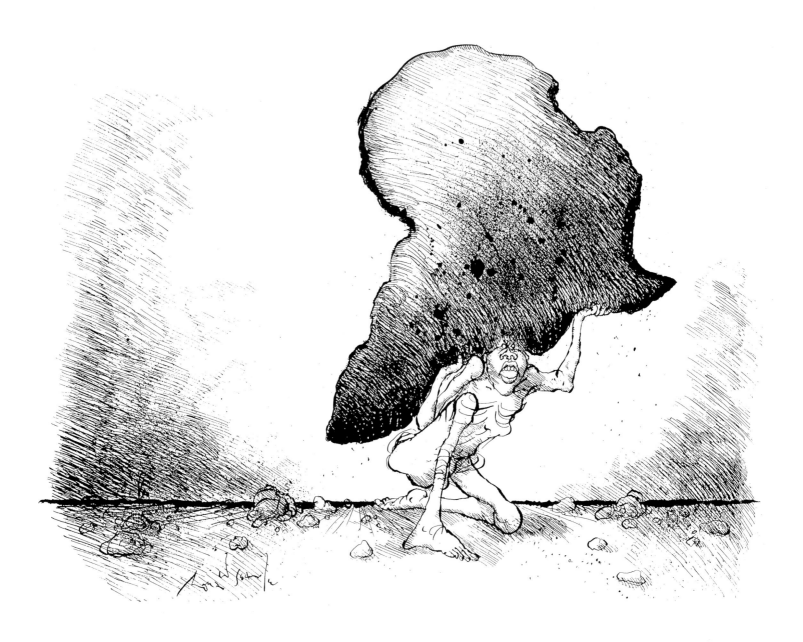

Atlas

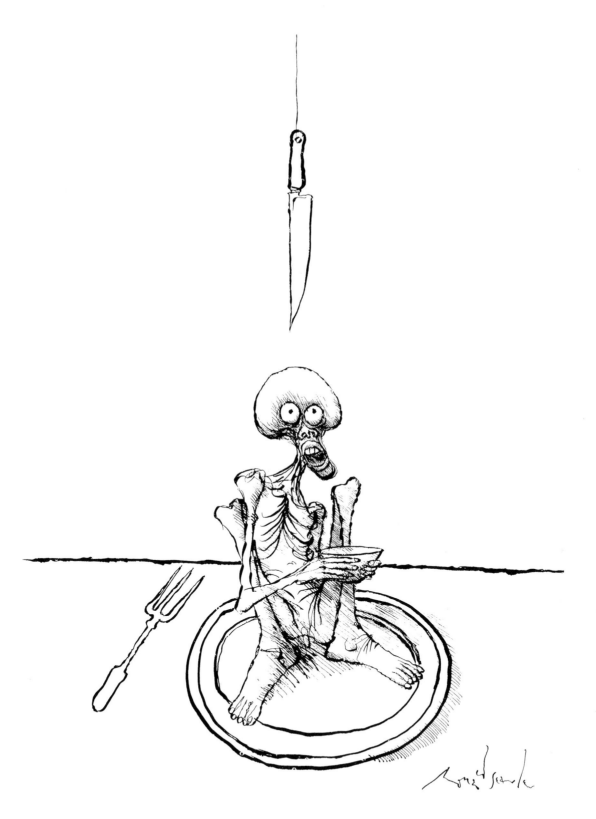

The knife of Damocles

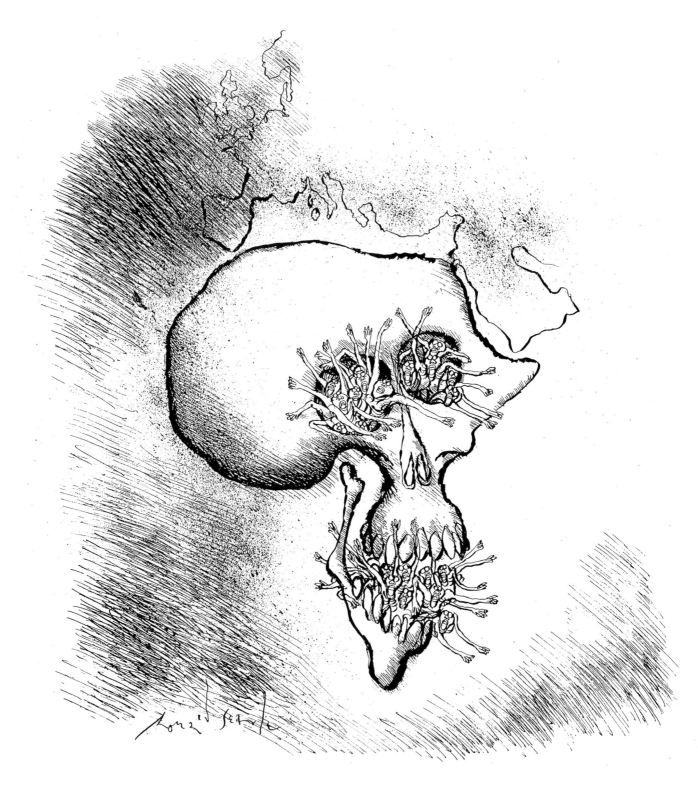

Africa

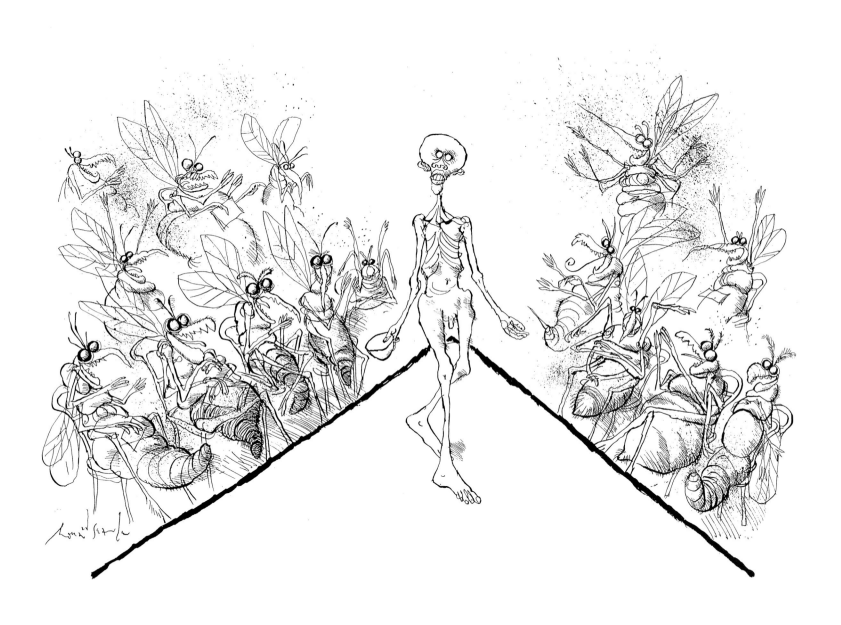

In style

OTHER COUNTRIES, OTHER PROBLEMS

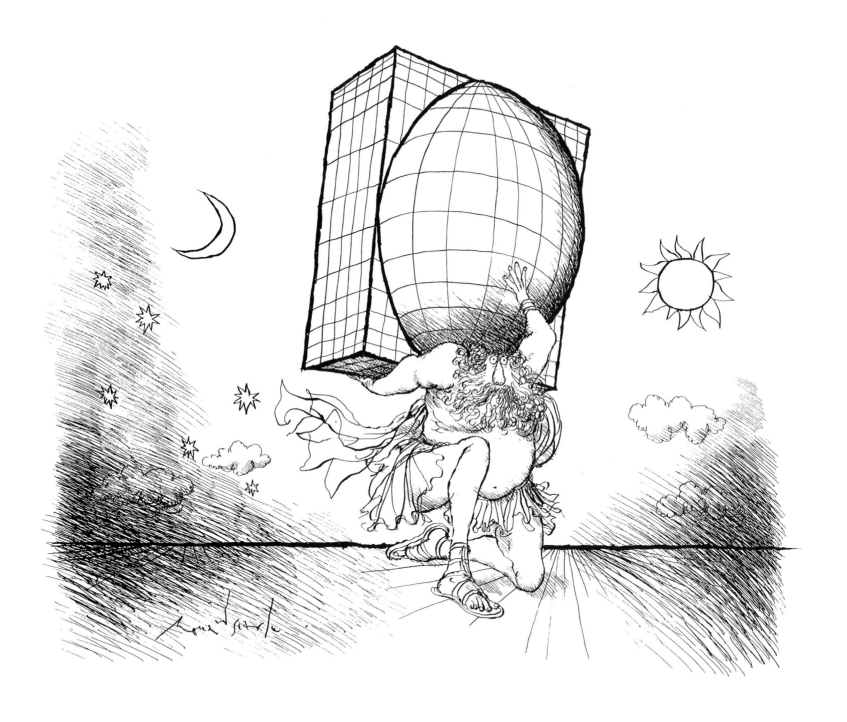

The world

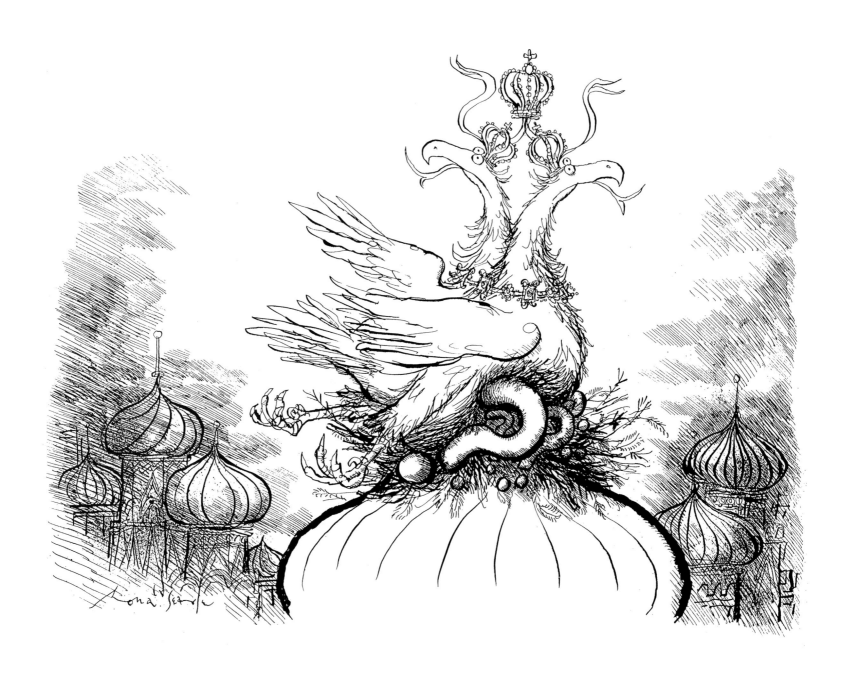

The new Russia

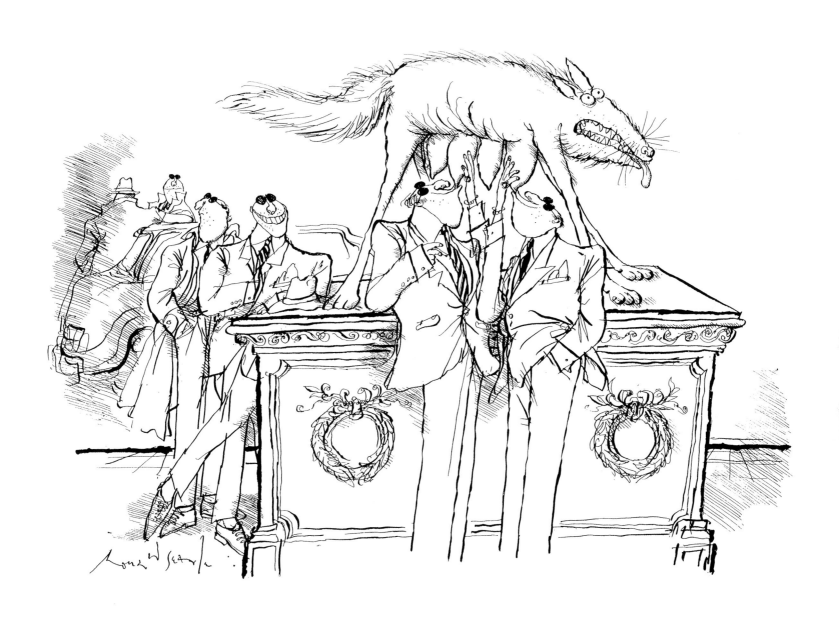

Romulus and Mafius

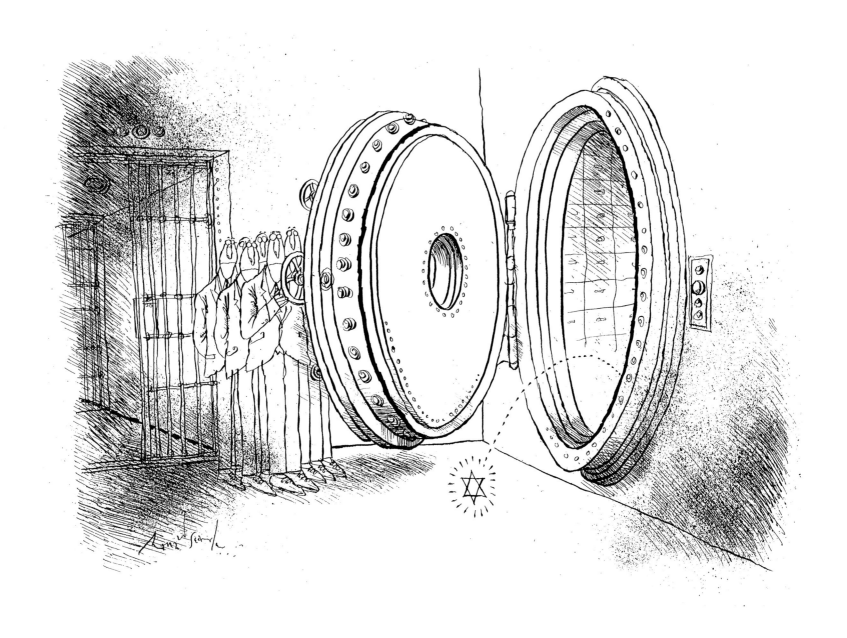

Switzerland and confiscated Jewish property

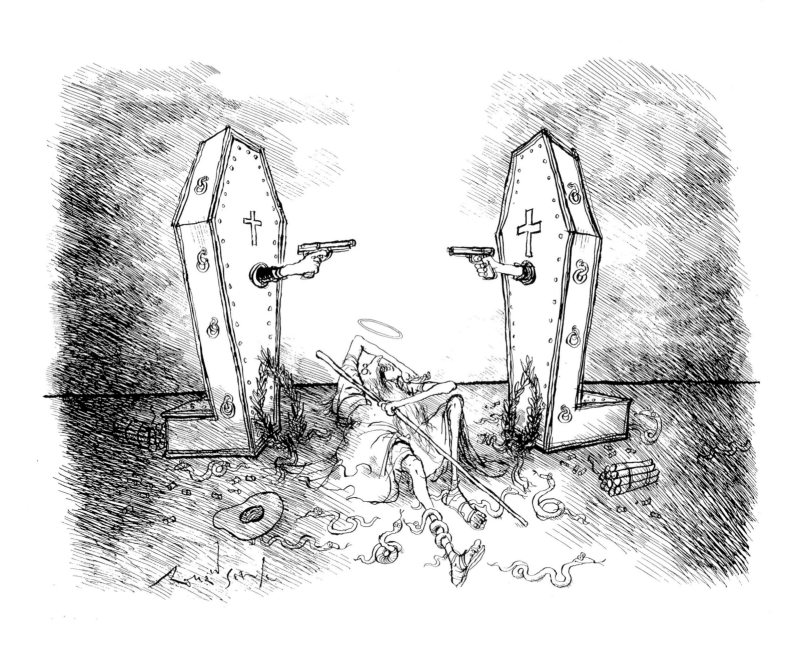

Ireland: The 30-year war of bigotry

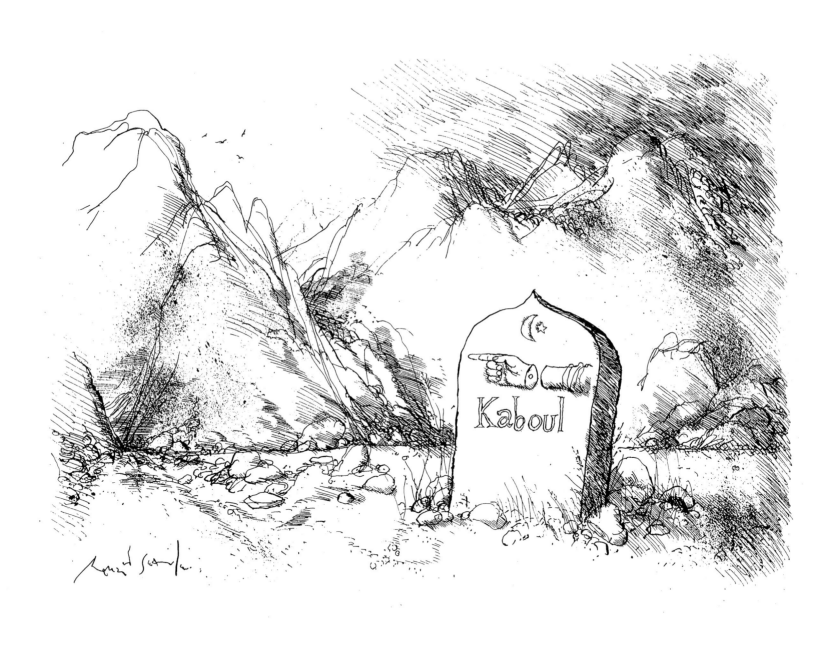

Afghanistan: The road to Paradise

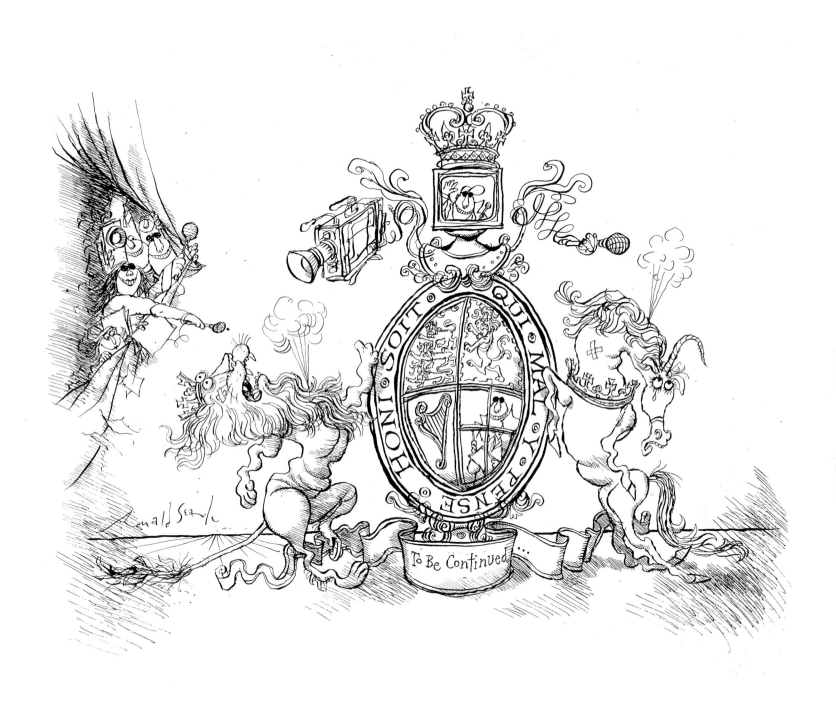

To Be Continued...

Buckingham Dallas

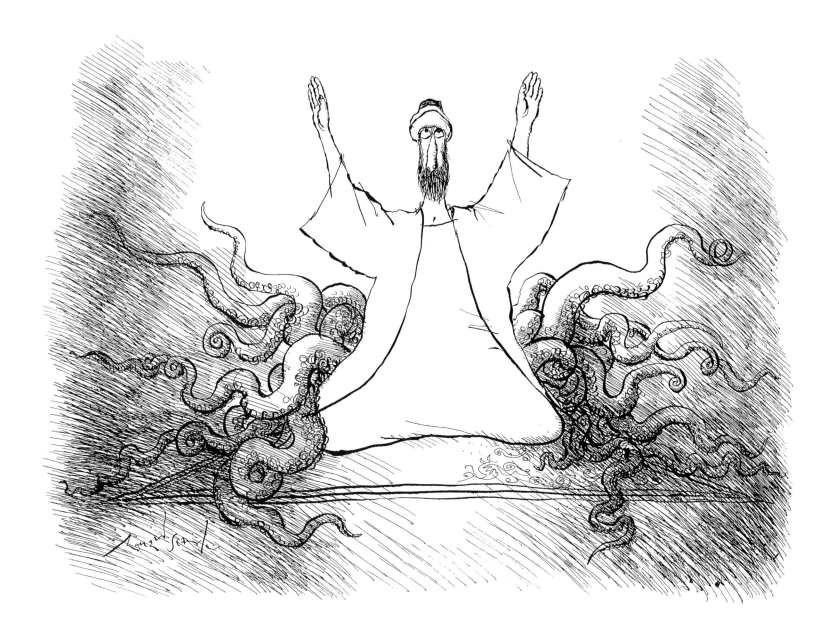

Iranian tentacles

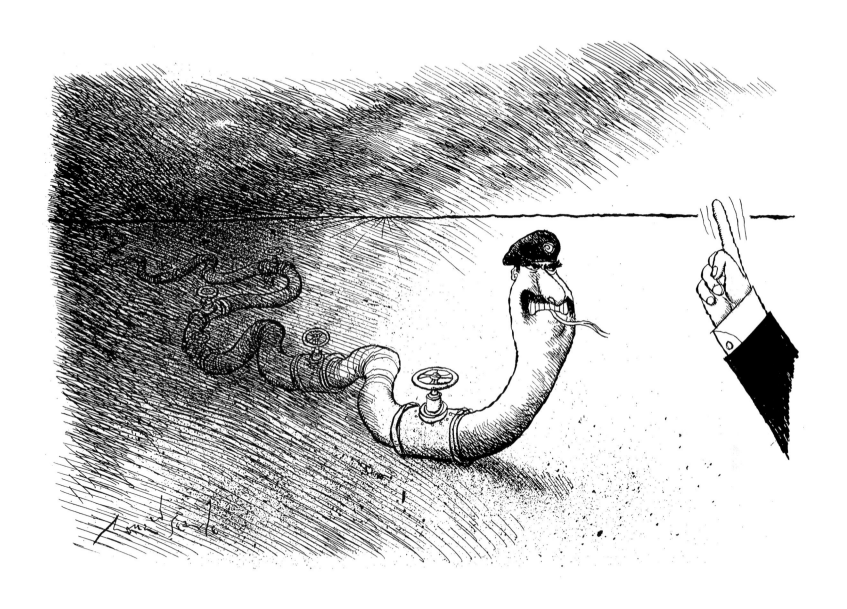

The Saddam line

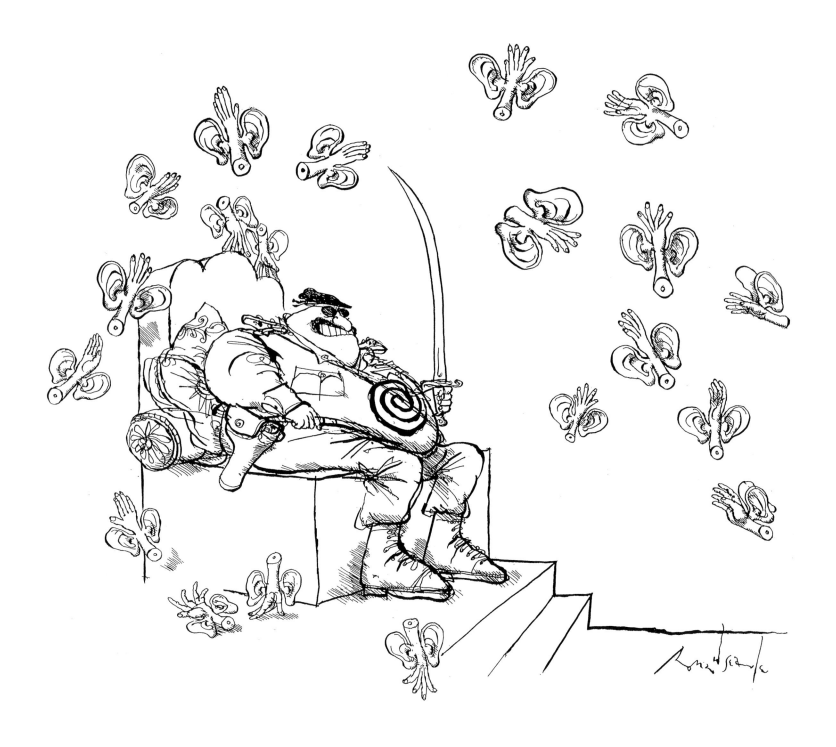

Ubuhussein

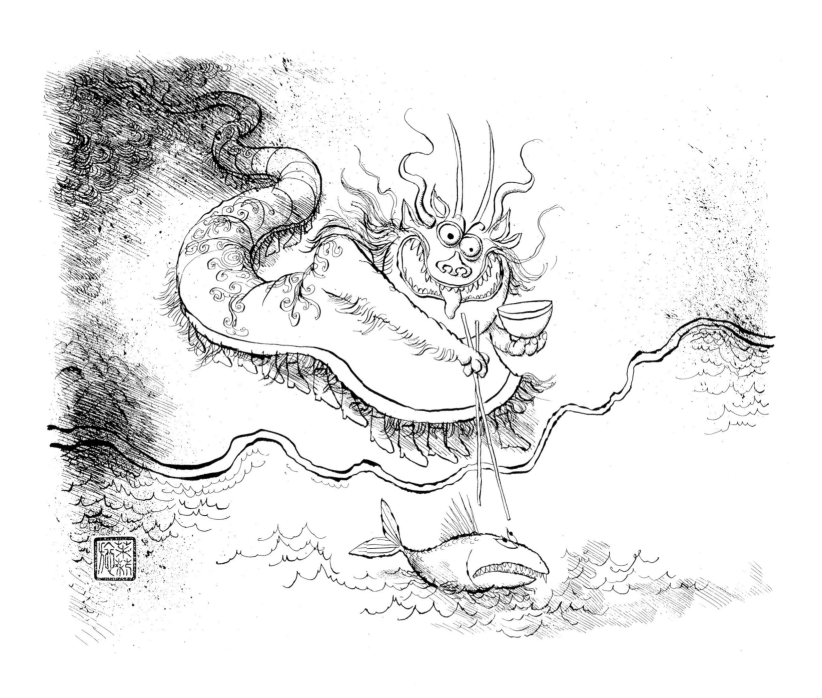

Chopsticks: China plays around with Taiwan

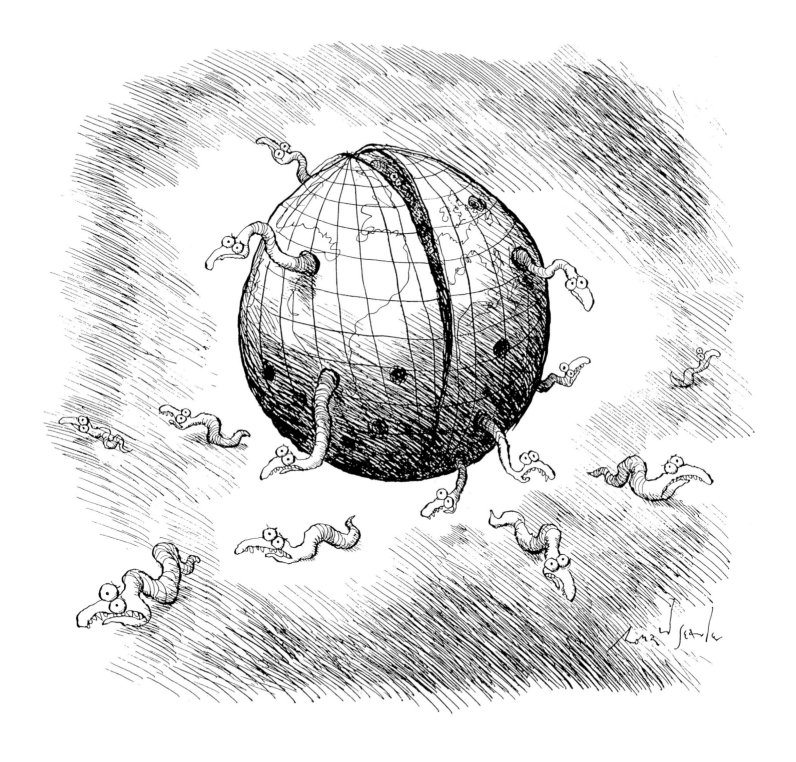

Fin de siècle

MONEY

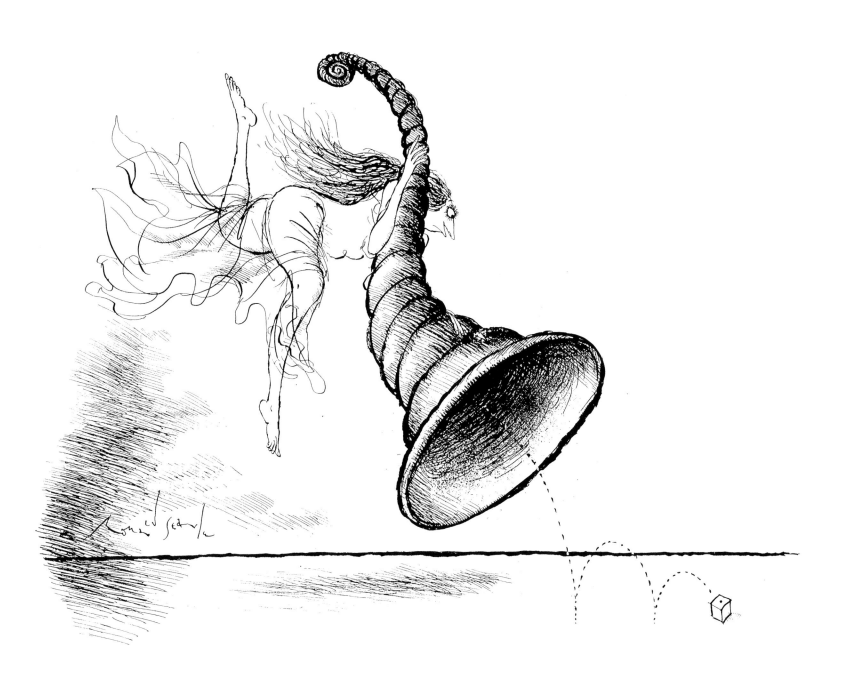

Recession

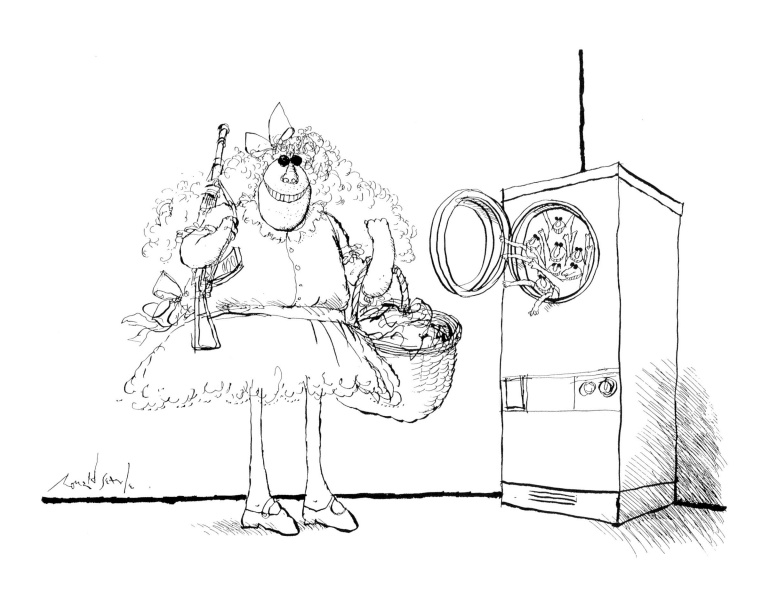

Snow White and the seven money launderers

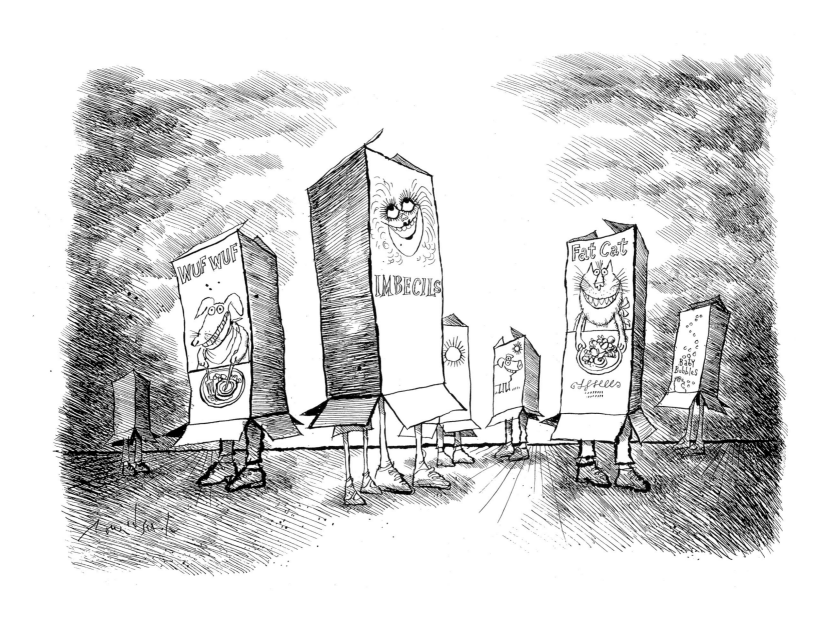

Consumer society

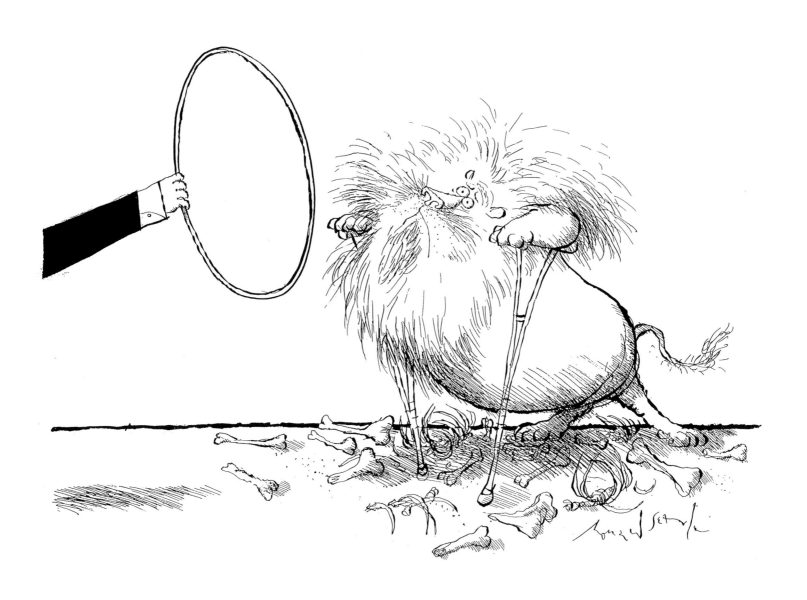

Debit Lyonnais Bank

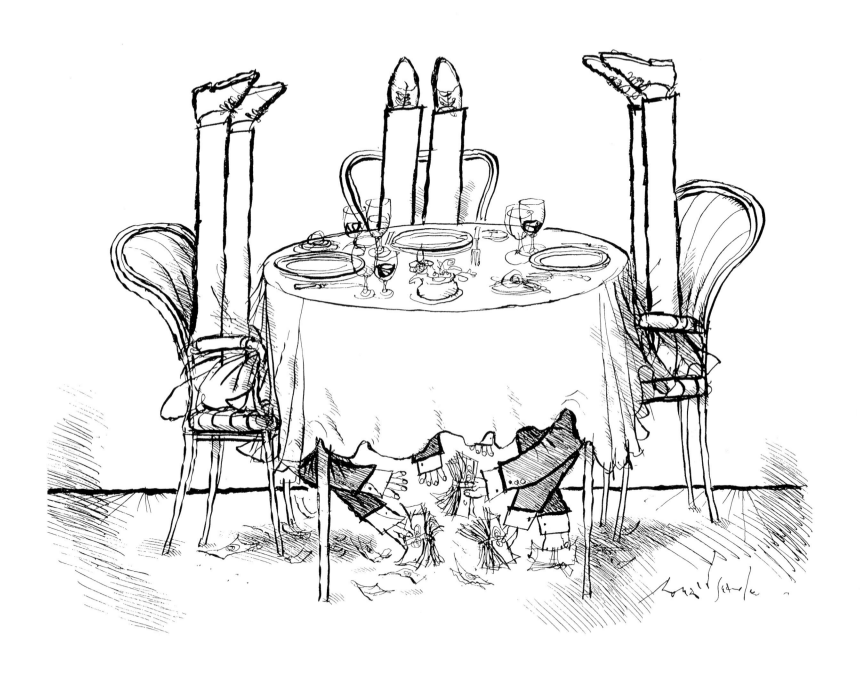

Business lunch

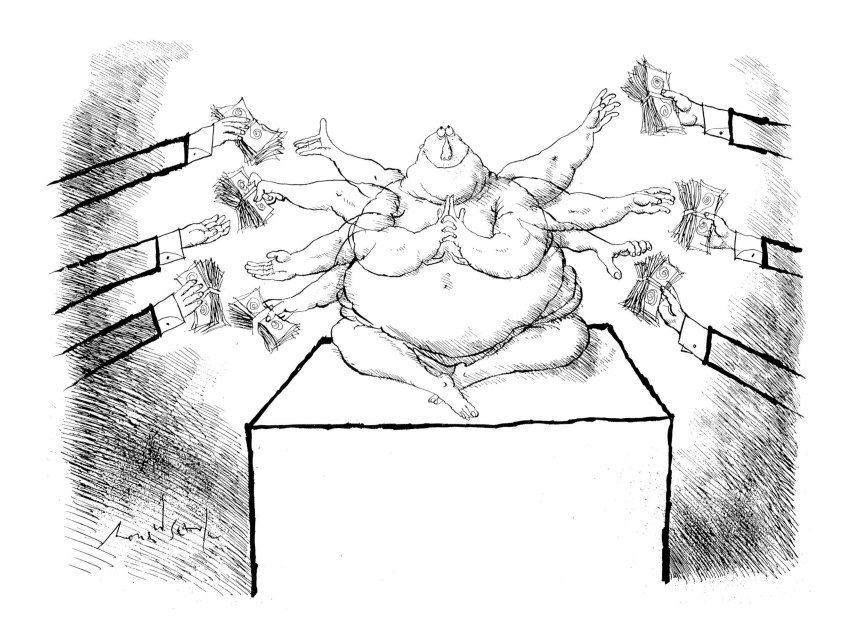

Party games

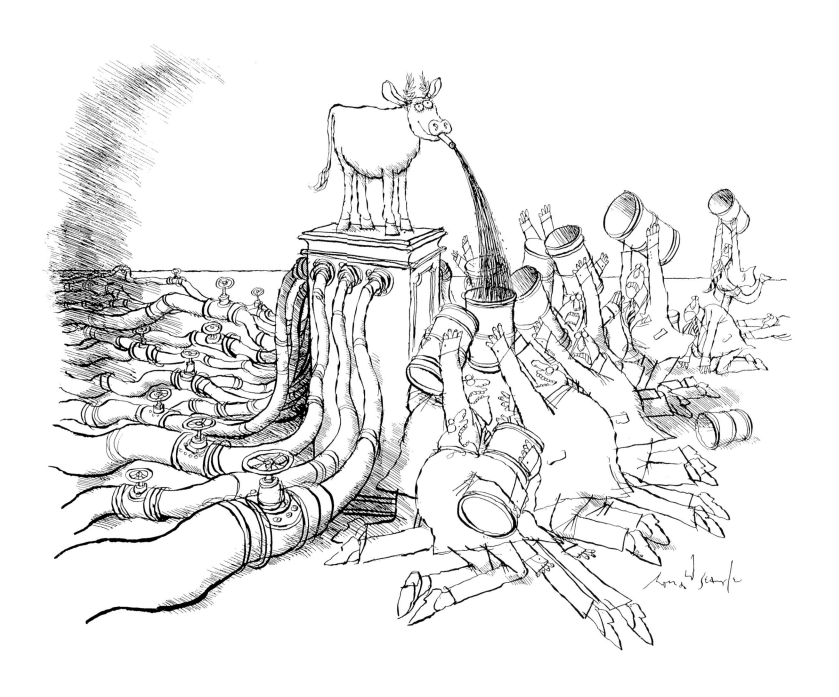

The golden calf

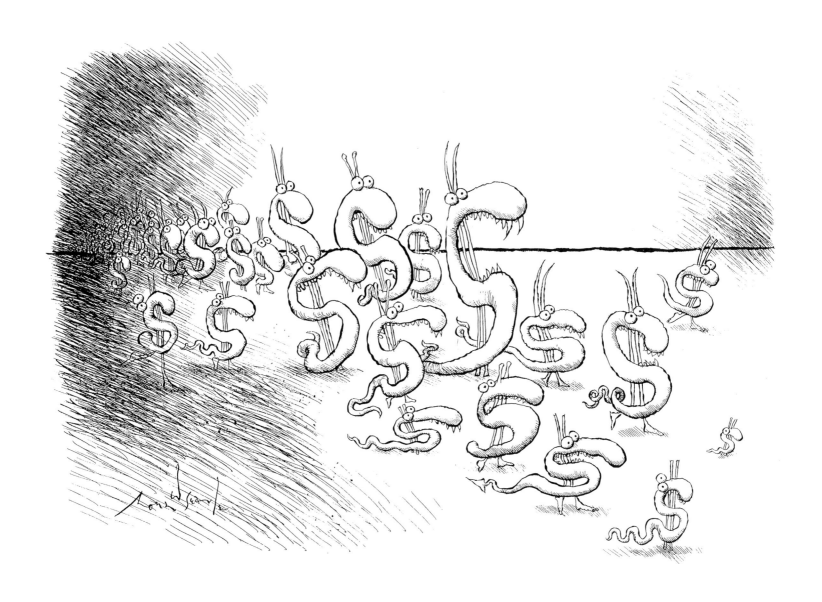

Crusade

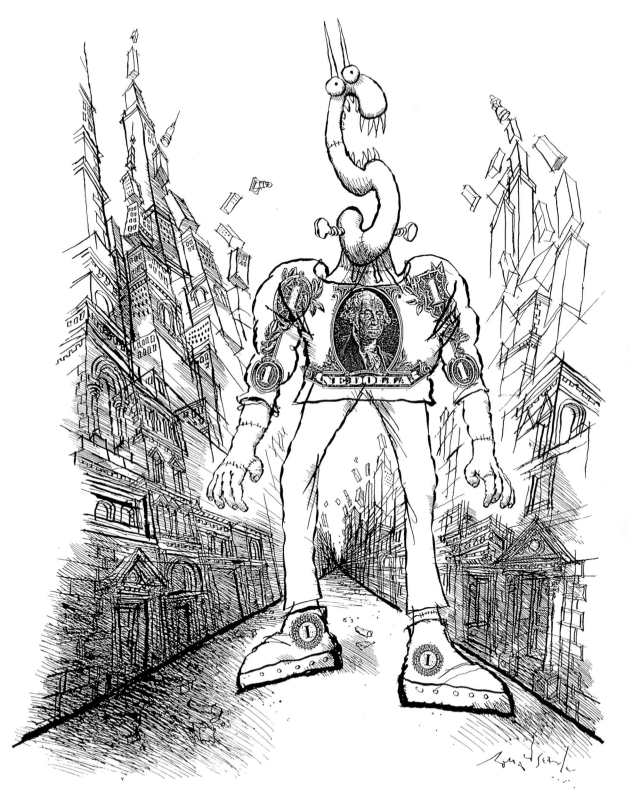

Clintonstein's monster

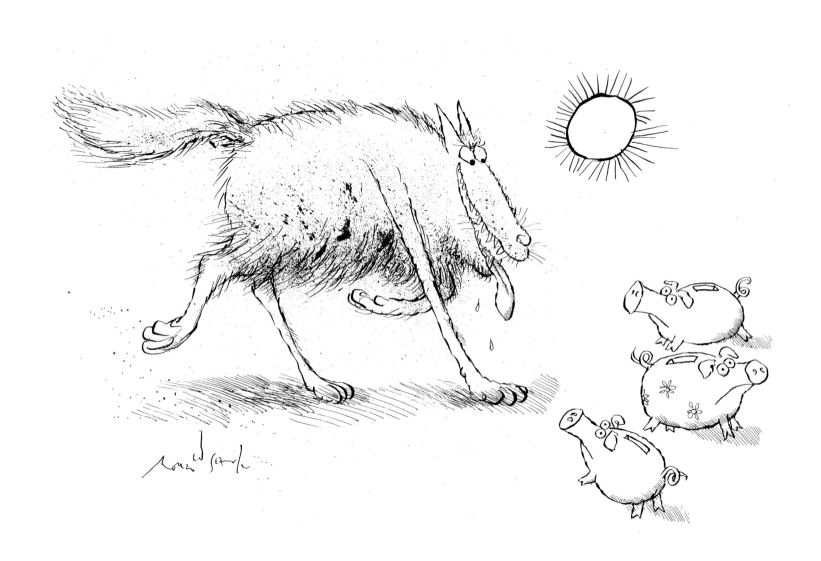

Hullo holidays

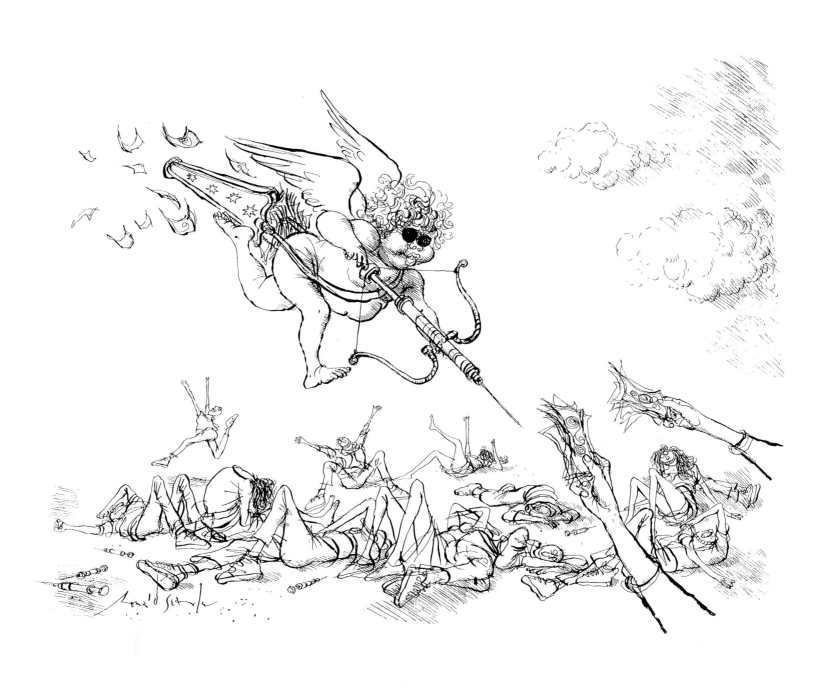

Dream merchant

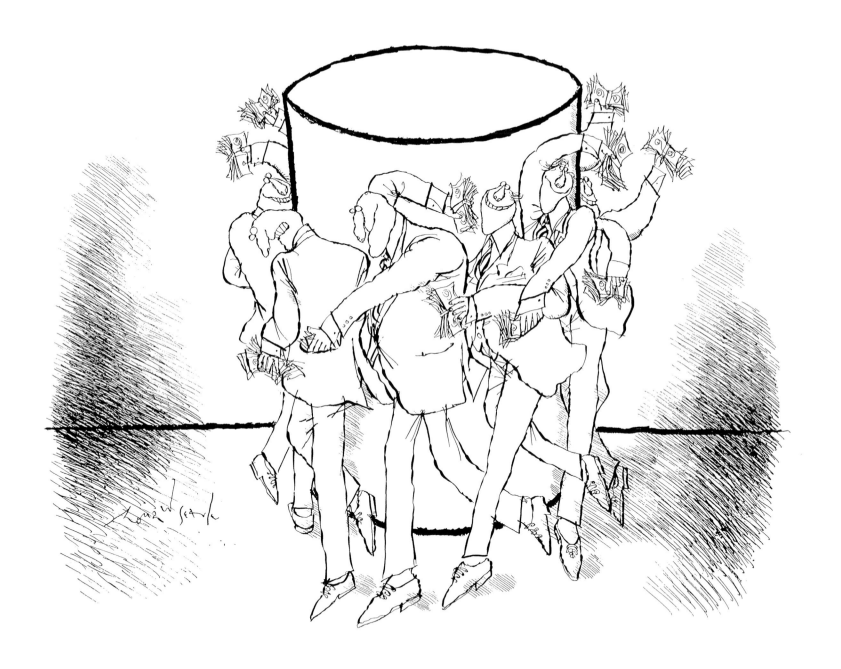

Vicious circle

SOCIETY GAMES

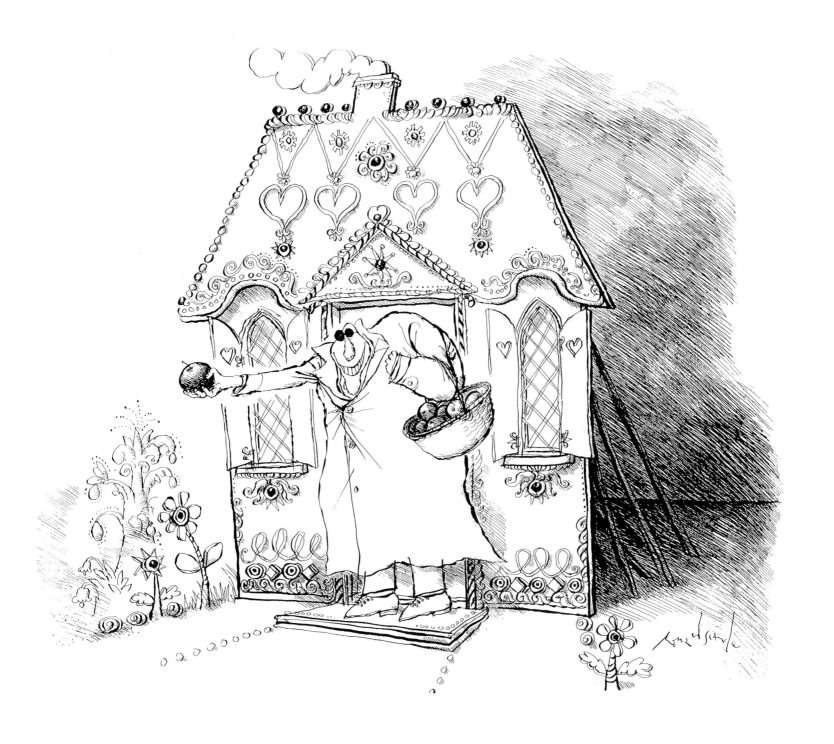

The dealer

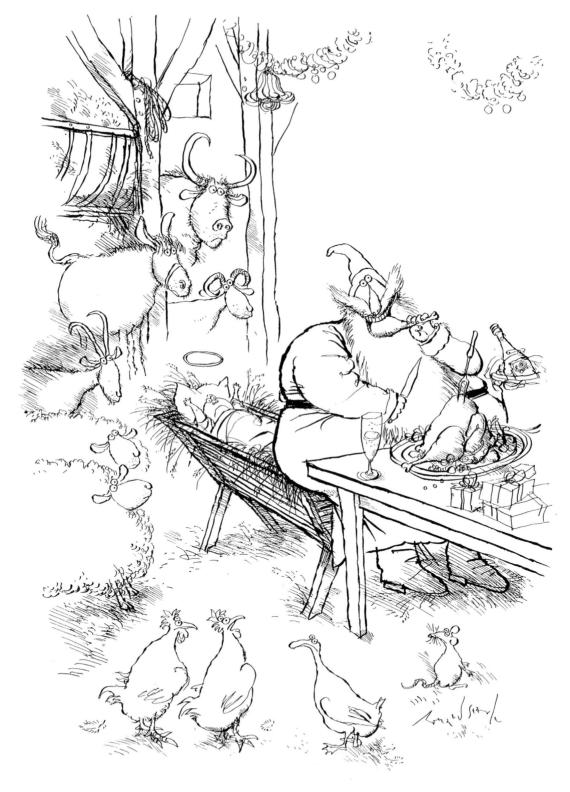

Christmas

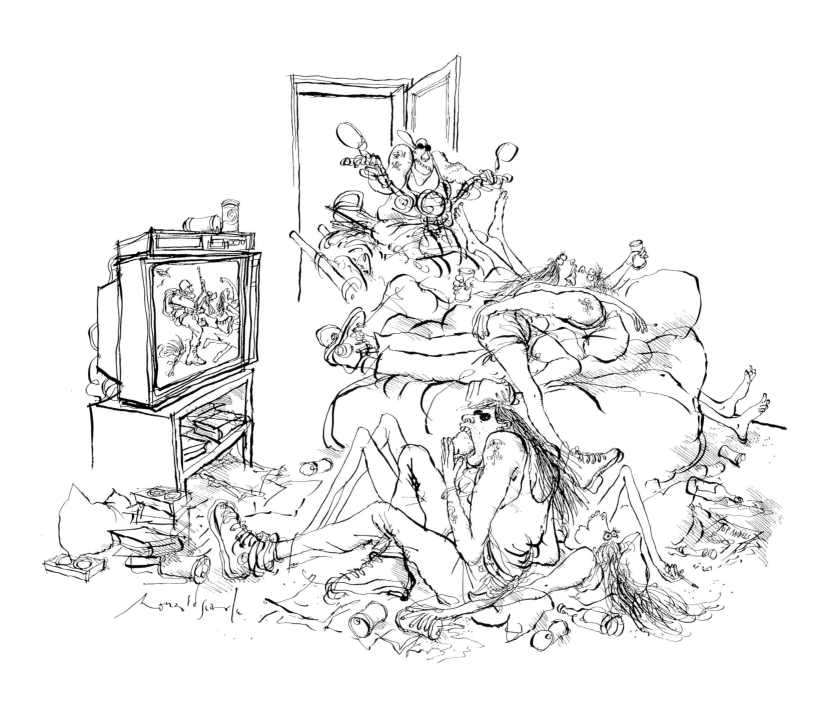

Children of the Gods

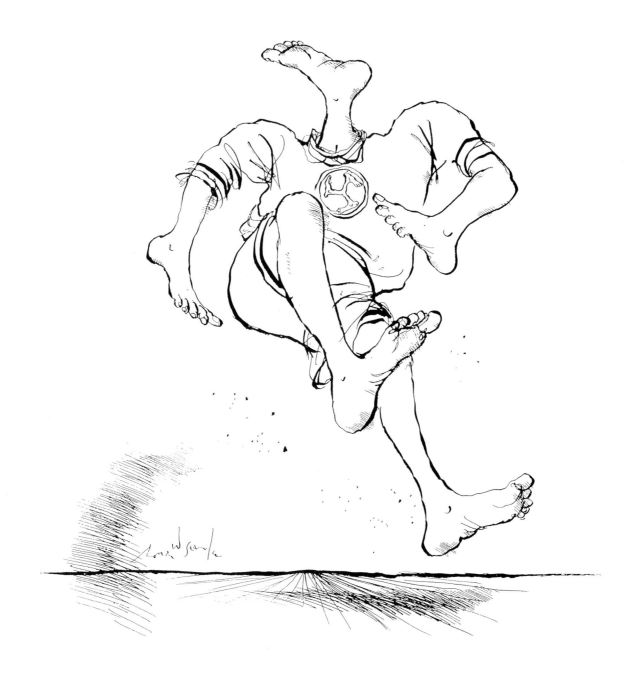

Football

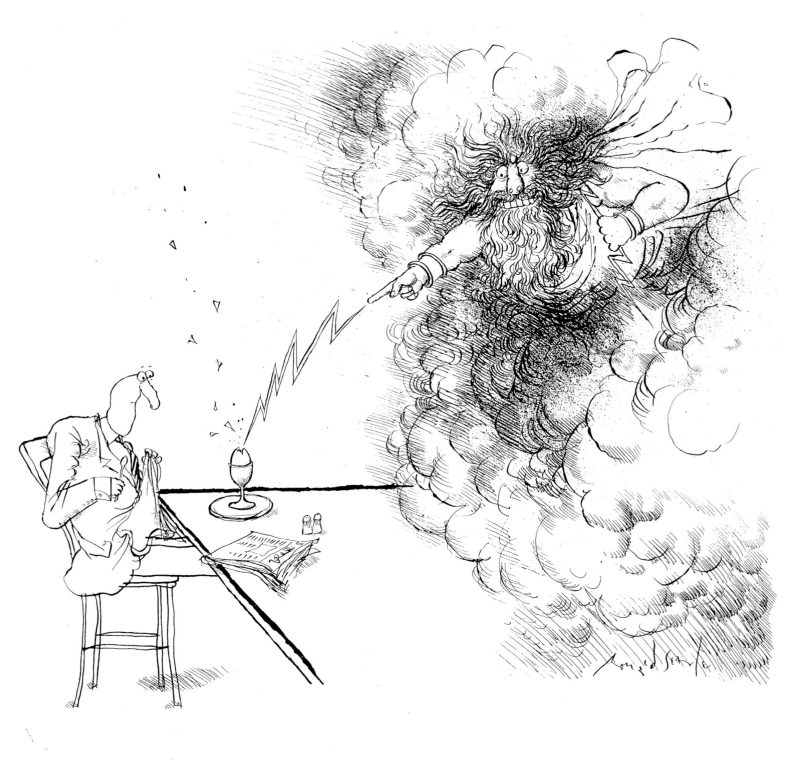

Twilight of the Gods

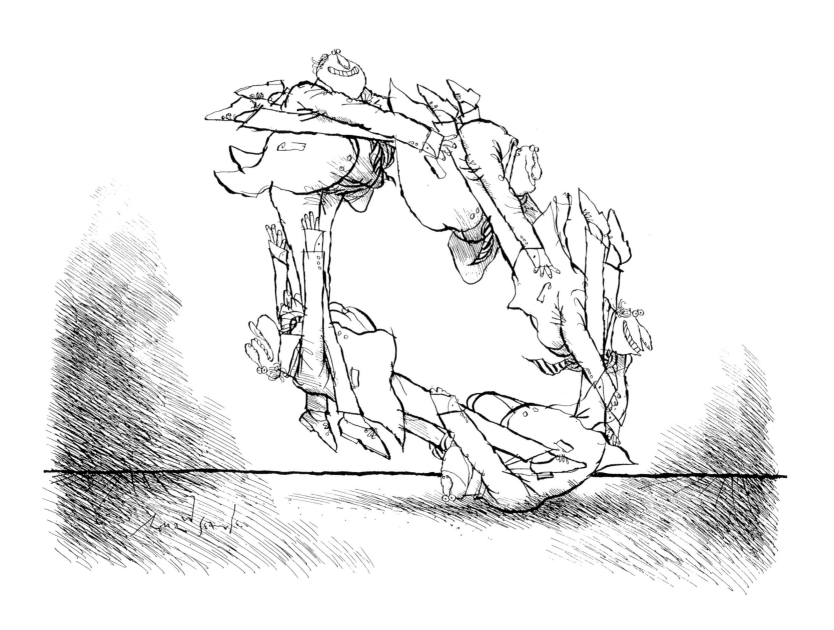

Wheeler-dealers

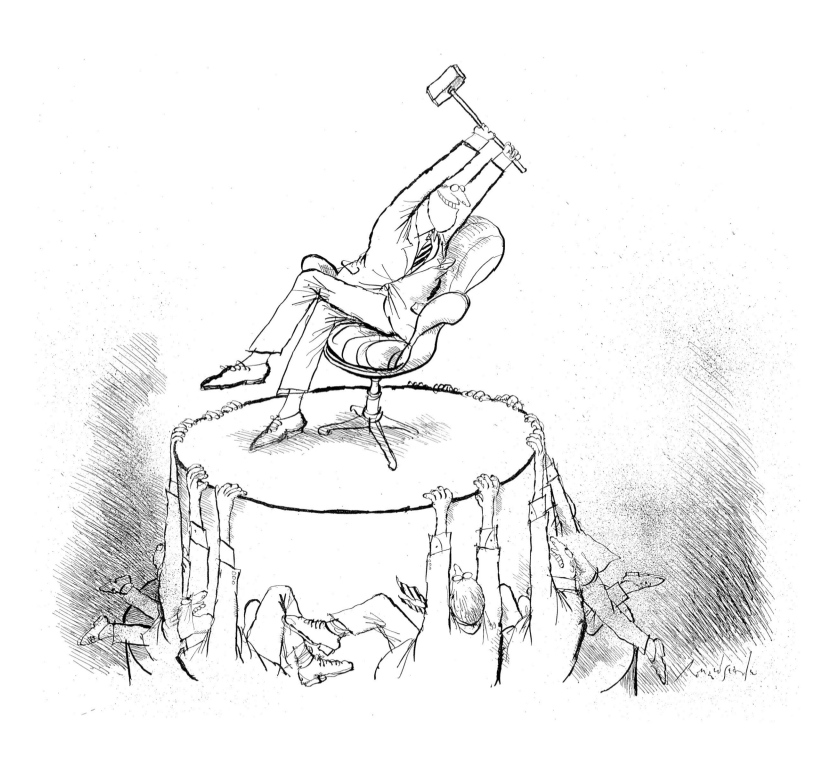

The top

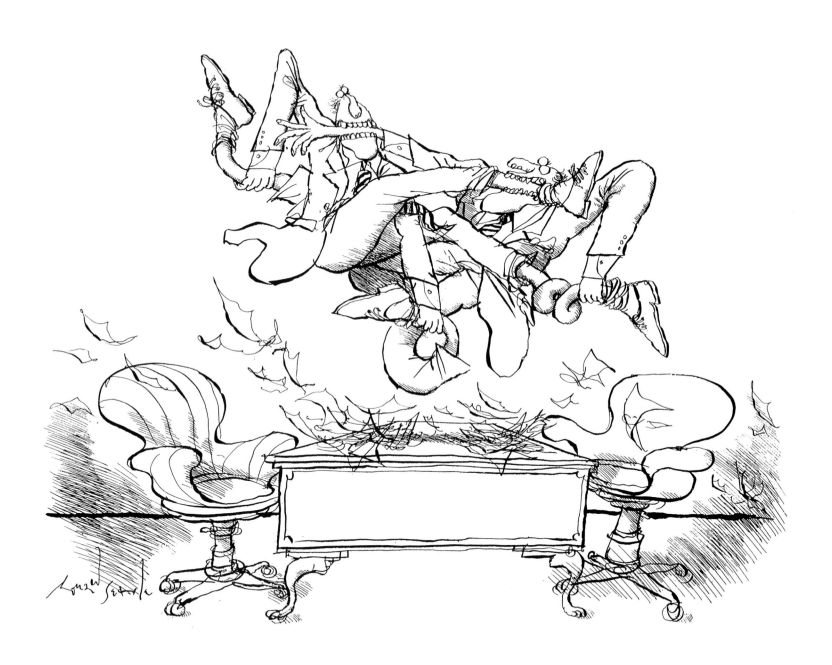

Friendly agreement

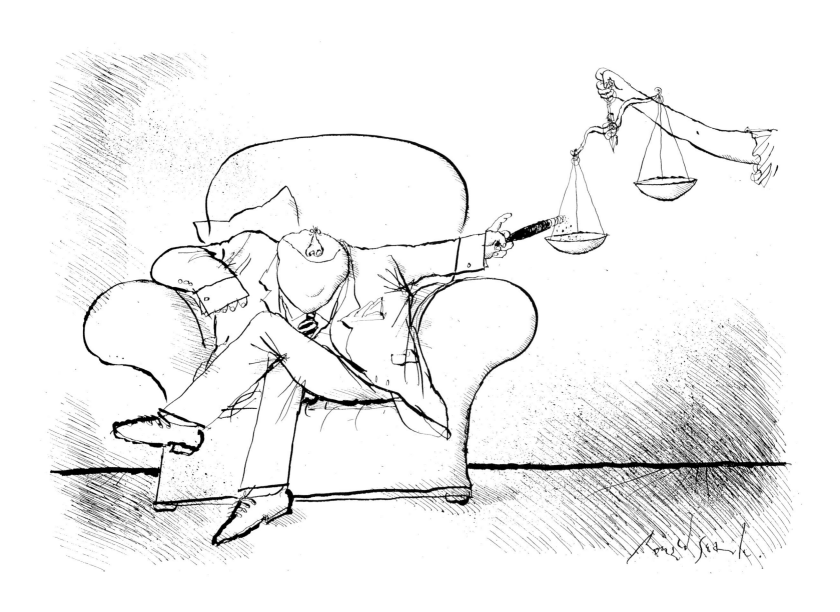

Influential person

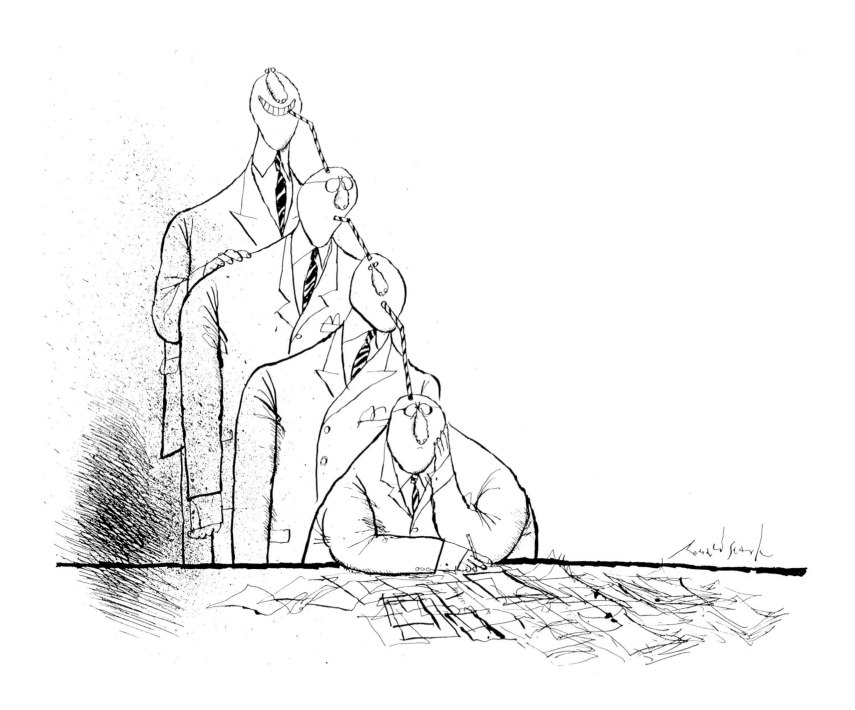

Hierarchy

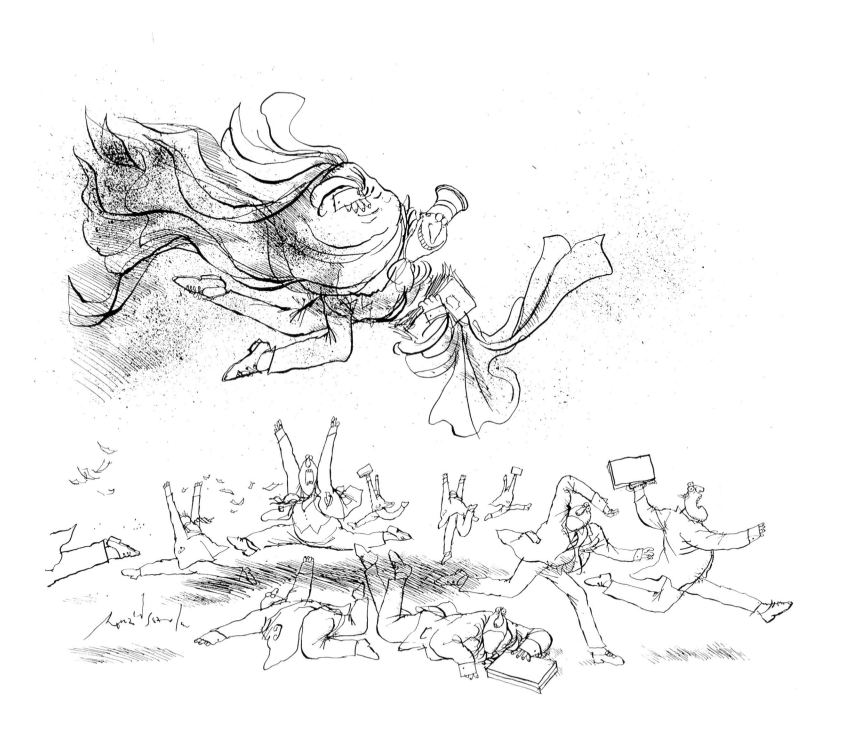

French law on the wing

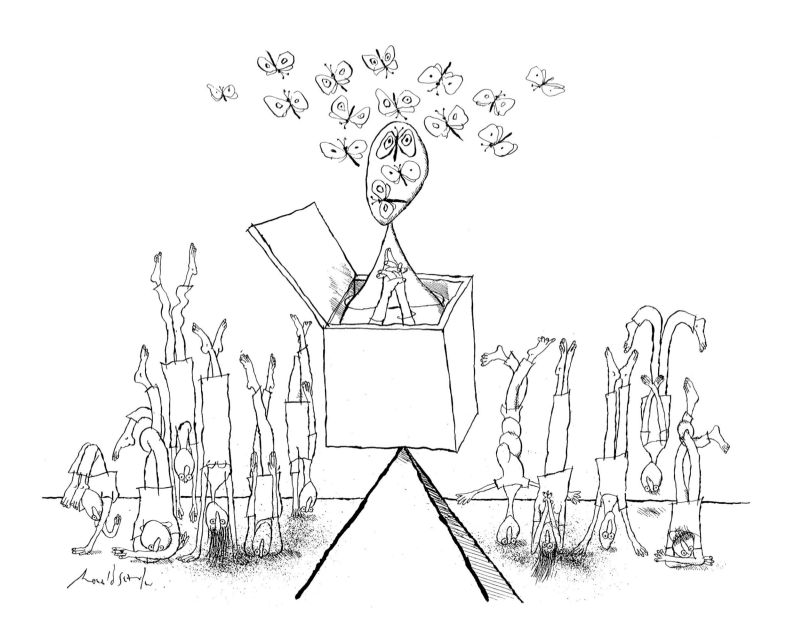

Cult

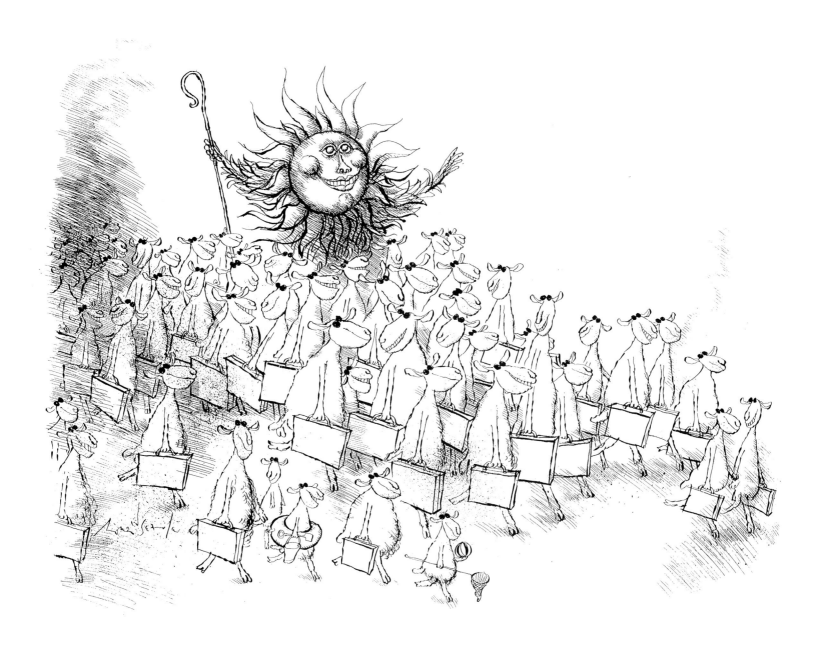

Summer migration

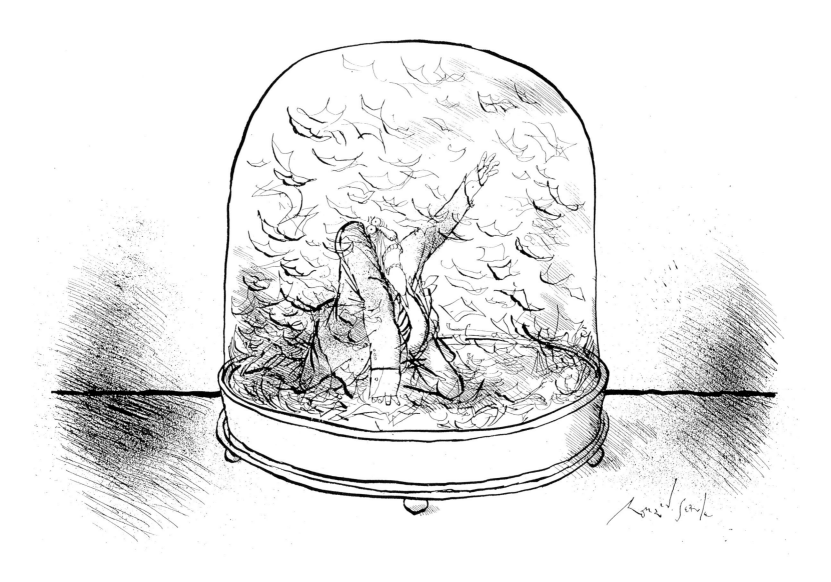

Purgatory

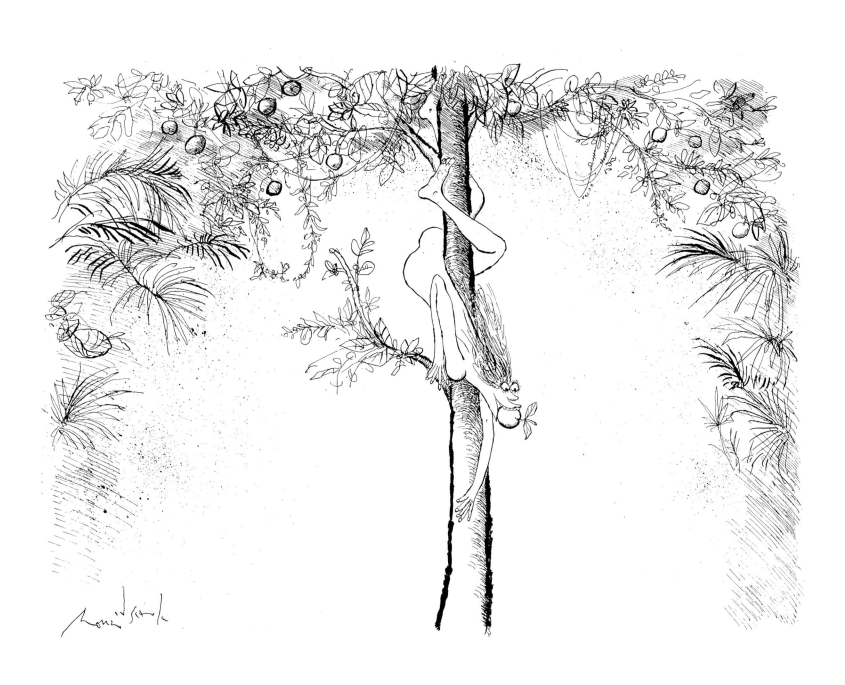

Politically incorrect

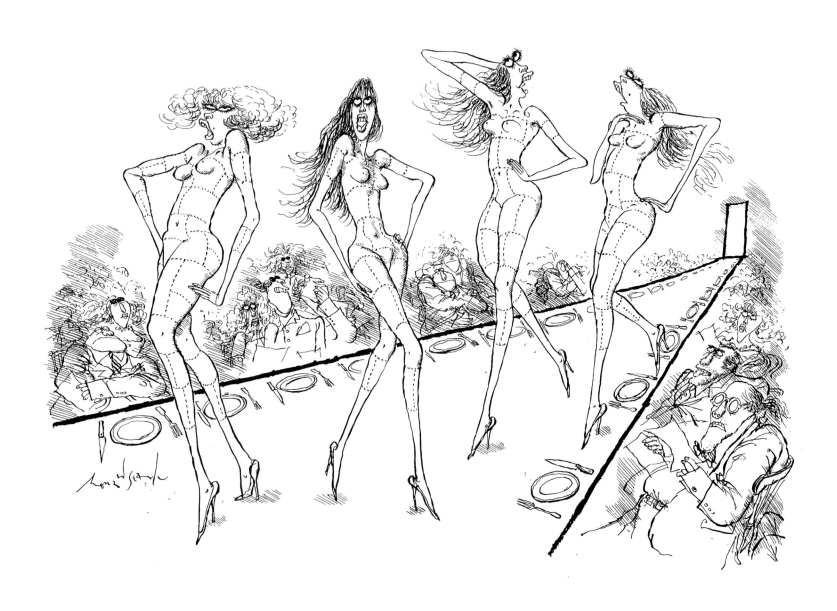

Choice morsels

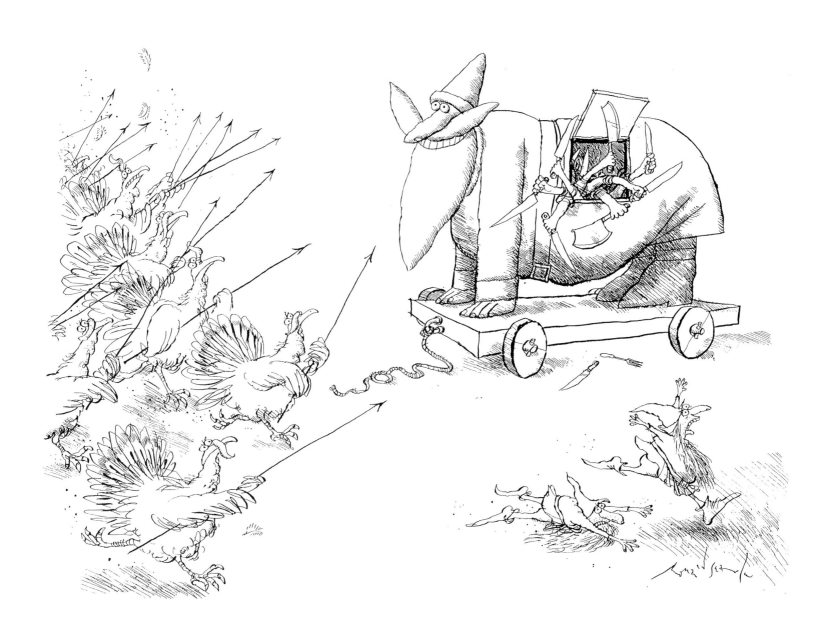

Christmas

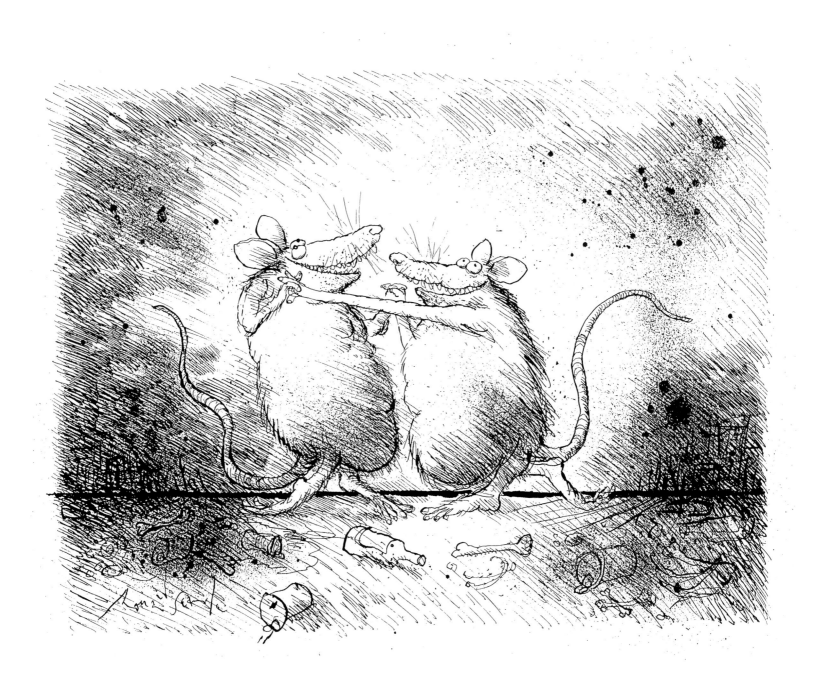

The good life!

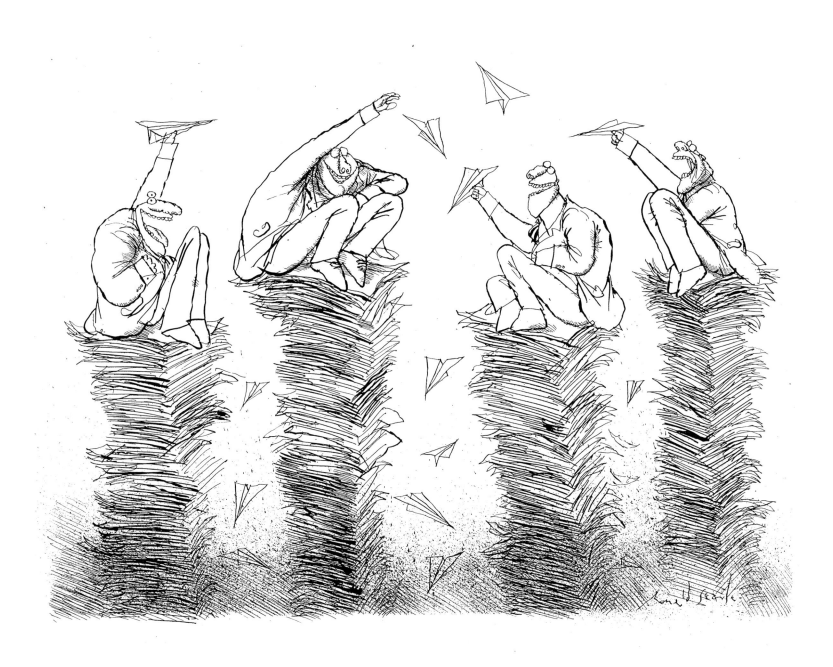

Bureaucratic stylites

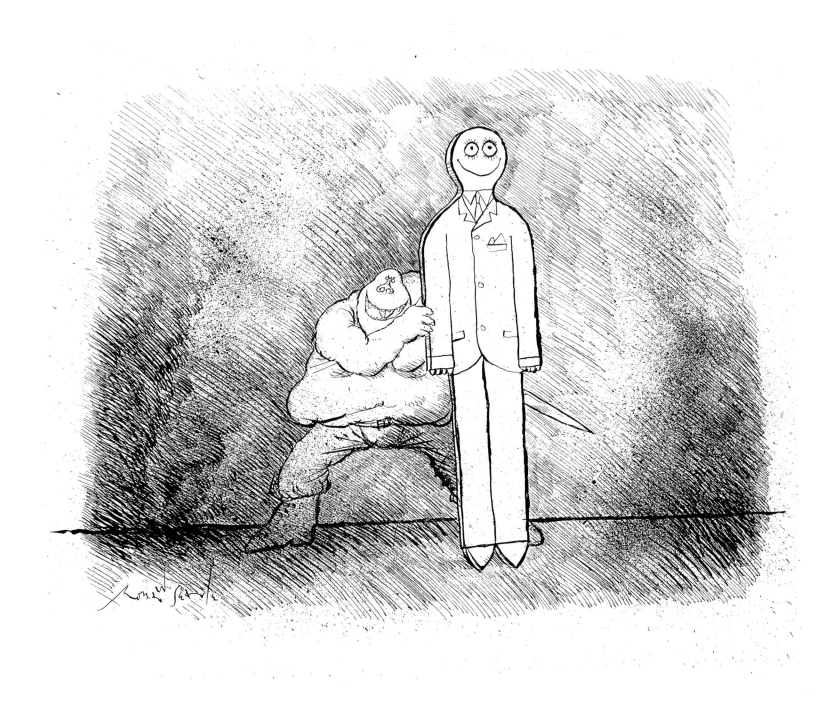

Homo sapiens

WAR AND PEACE

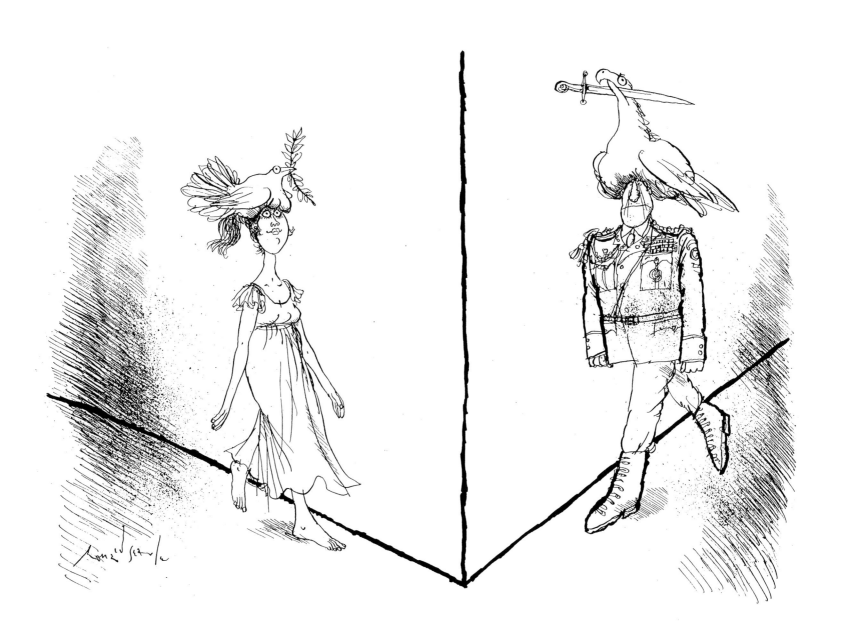

Summit meeting

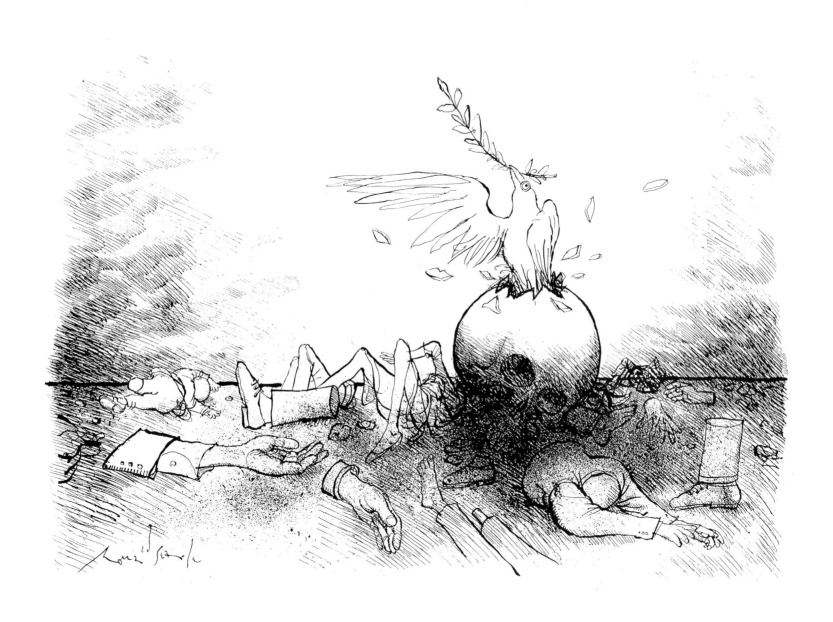

Phoenix

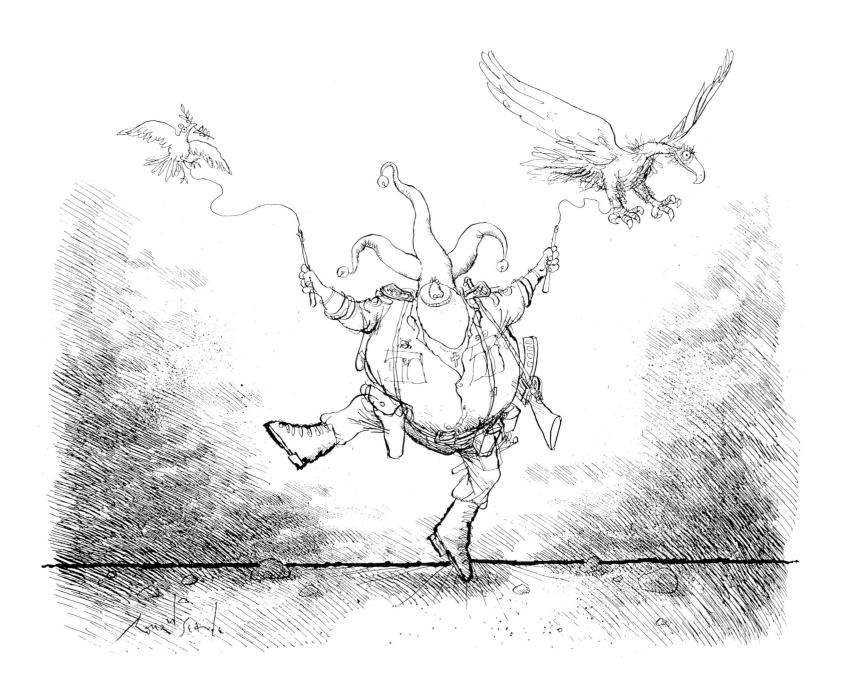

The buffoon

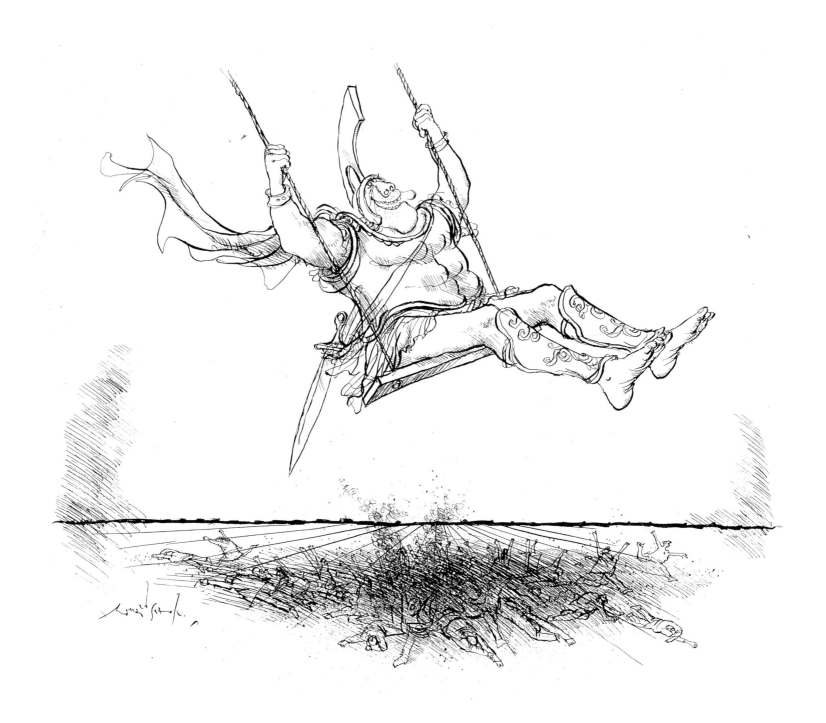

Swingtime

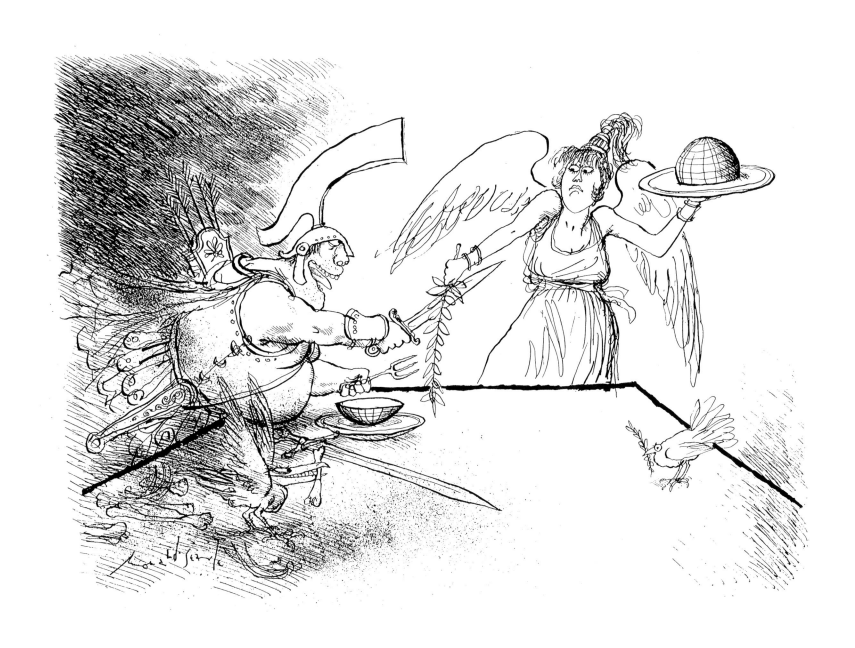

Glutton

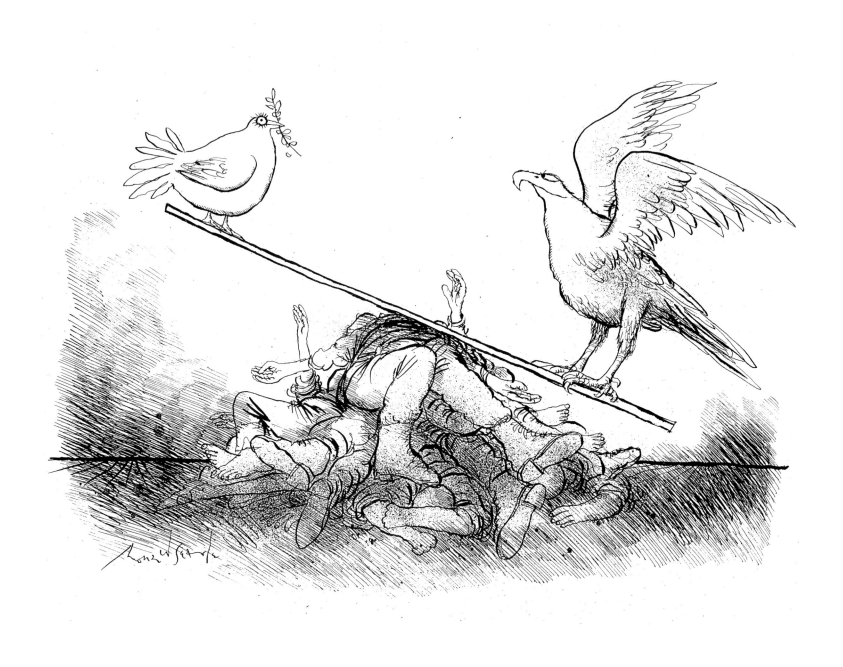

See-Saw

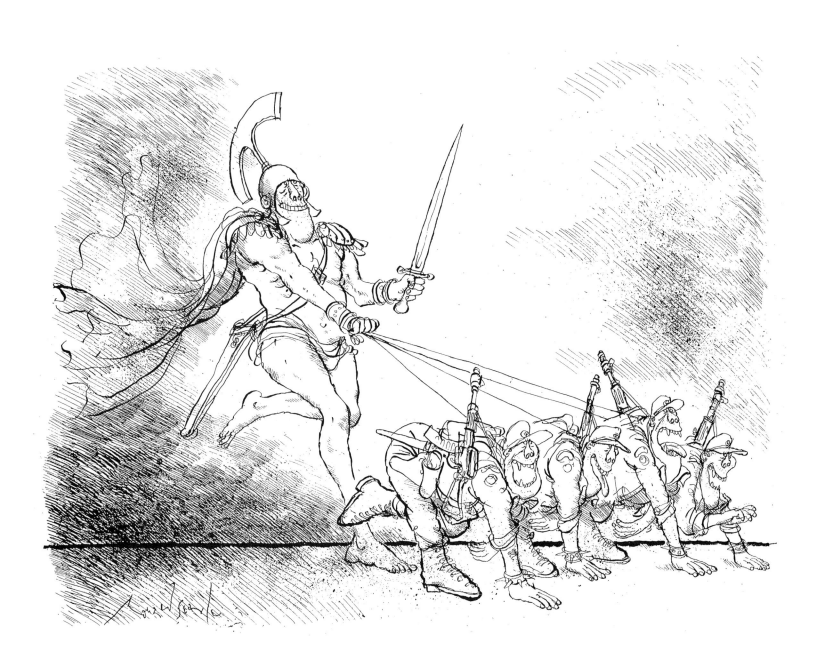

Mercenaries

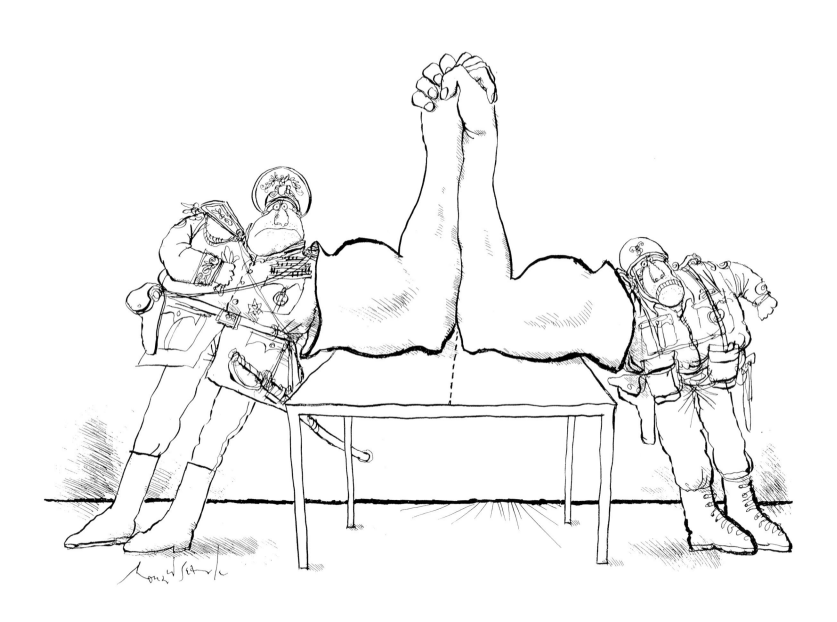

Only a small conflict

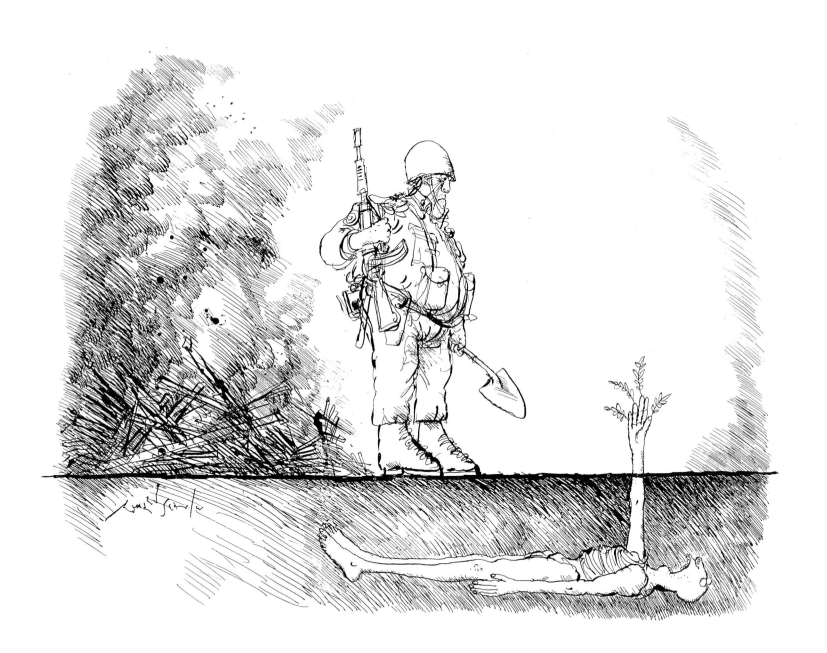

Provocation

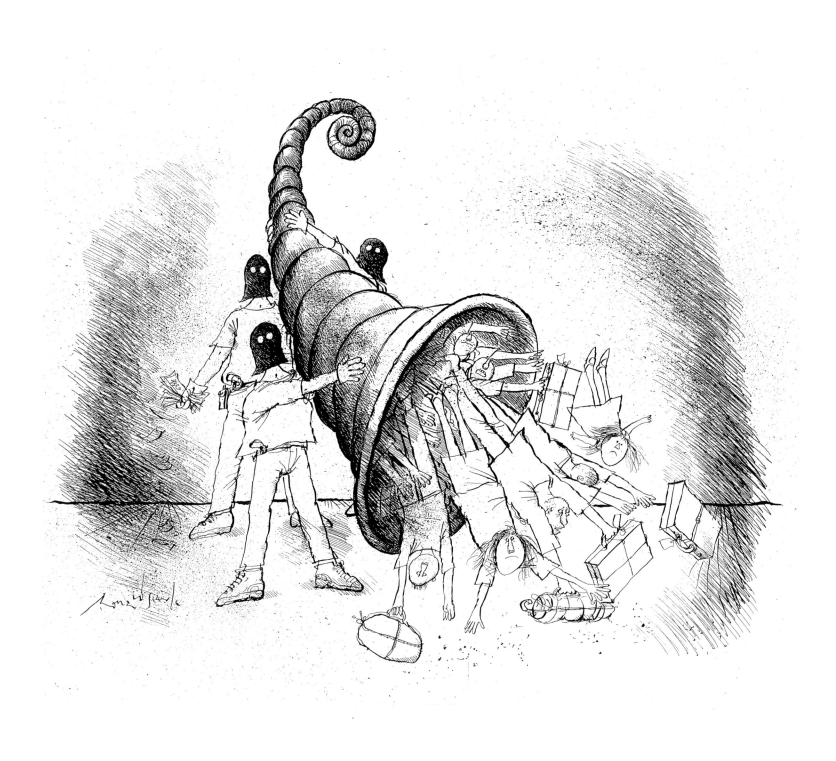

Refugees

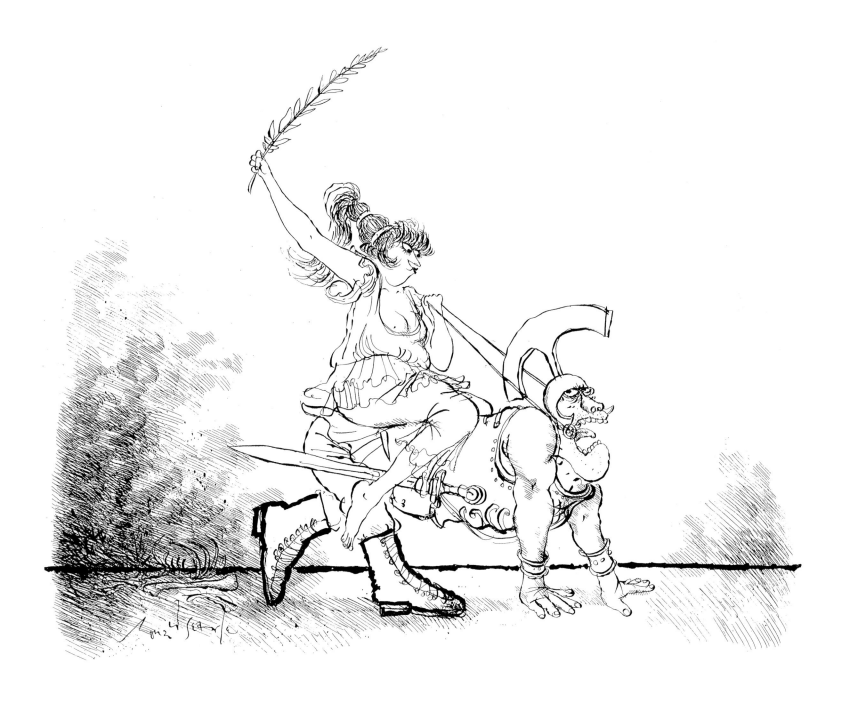

The tamer

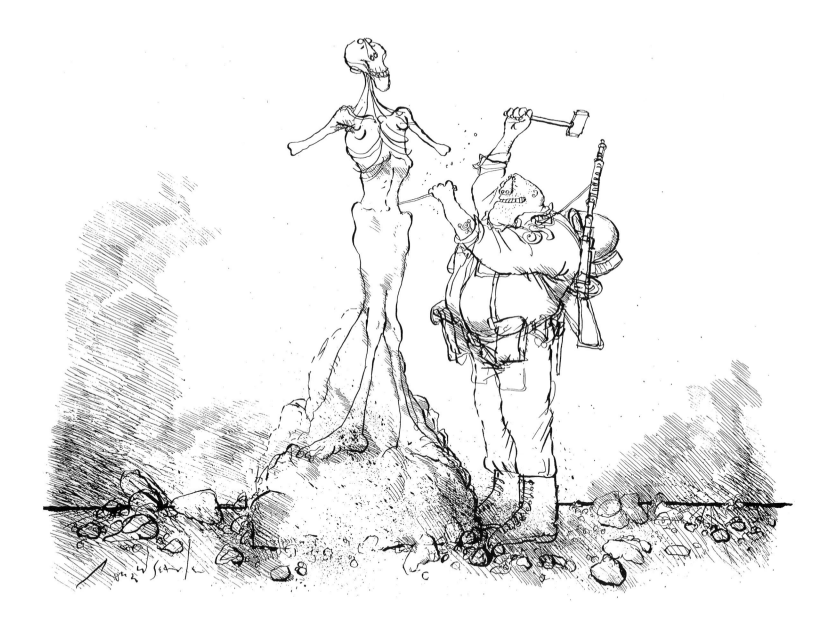

Pygmalion

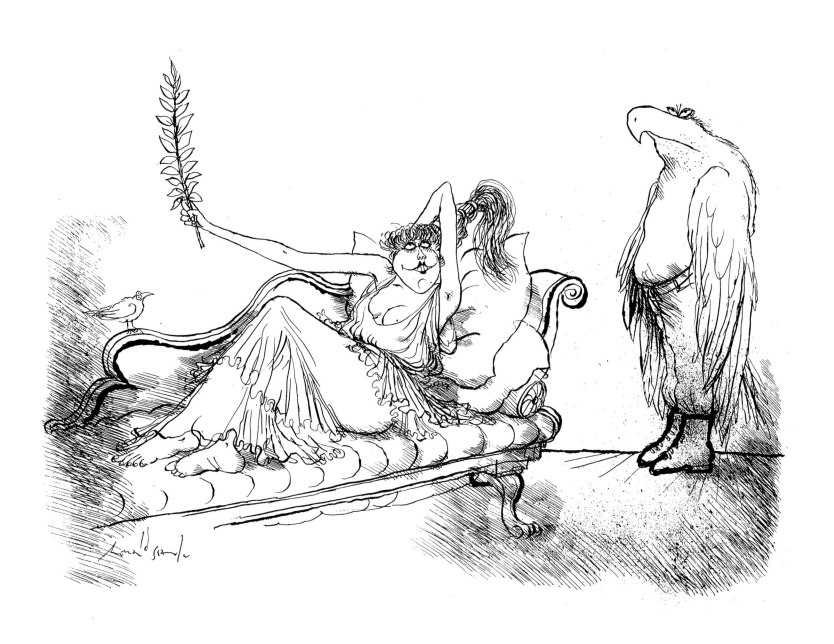

Beauty and the beast

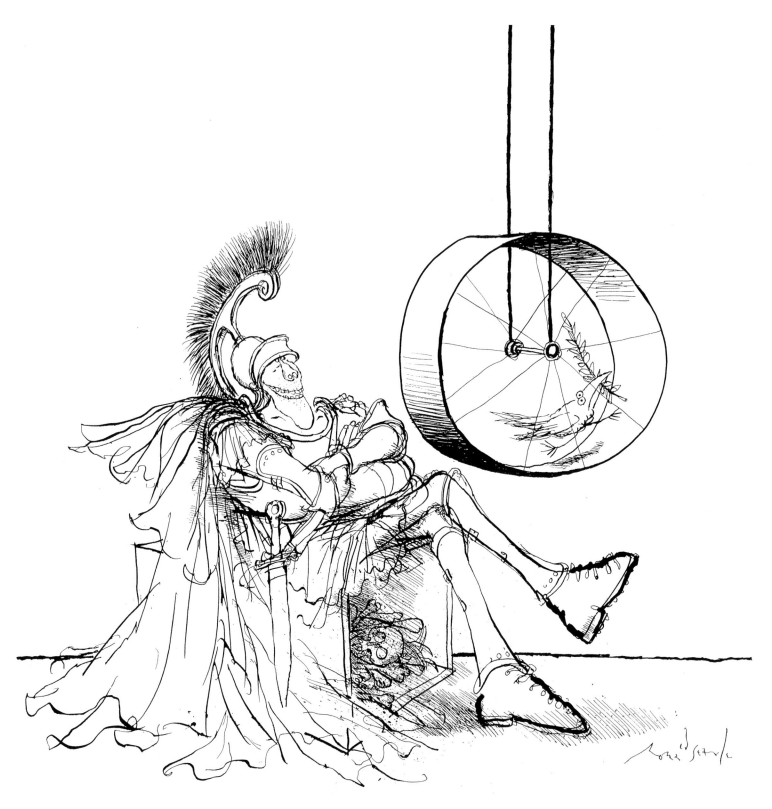

War and Peace

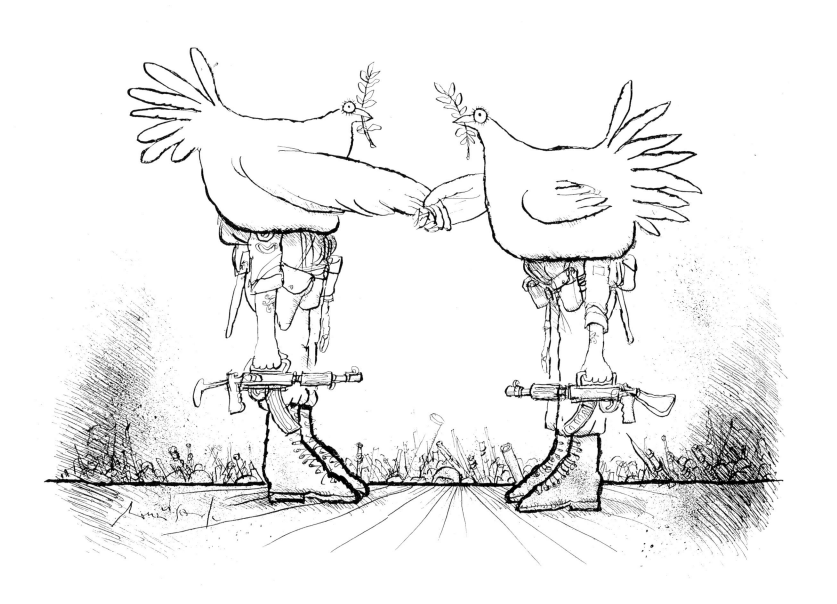

Provisional peace

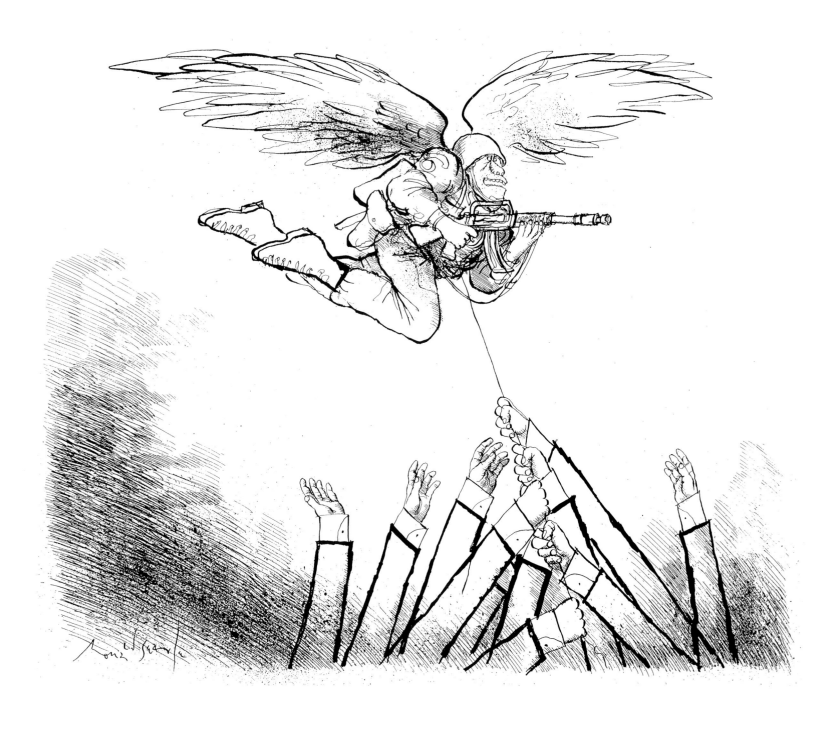

Killer kite

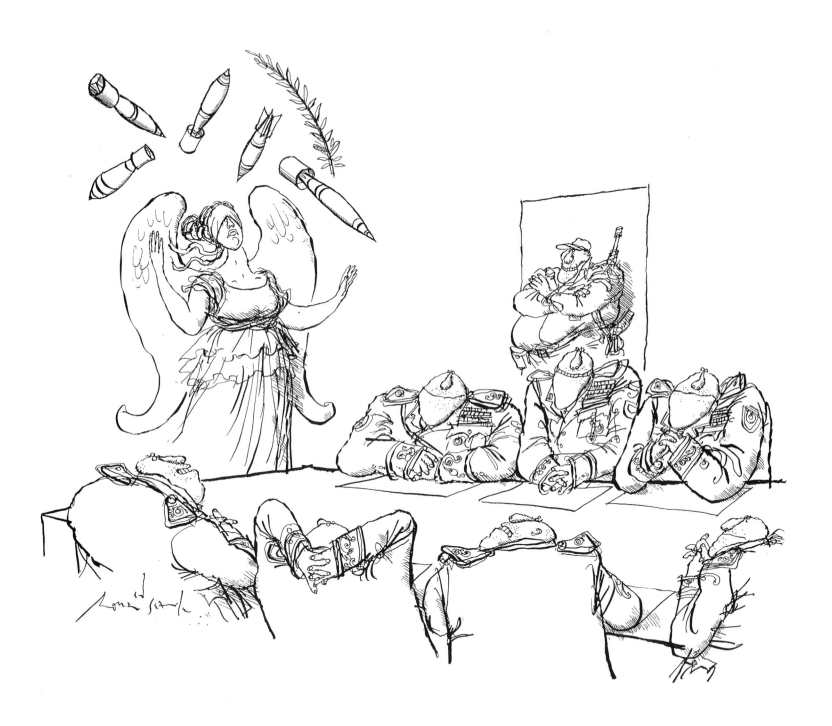

Timeout

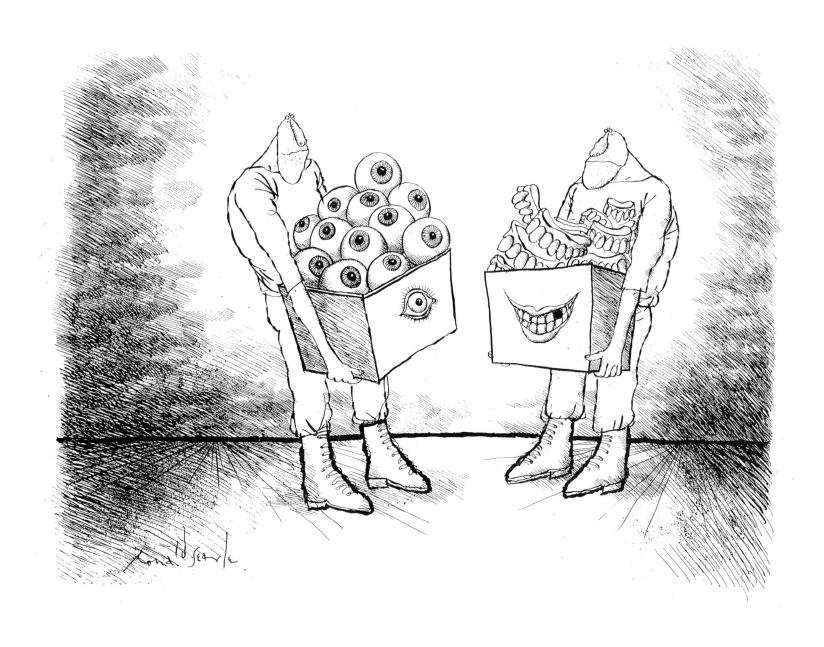

Lottery—the winners

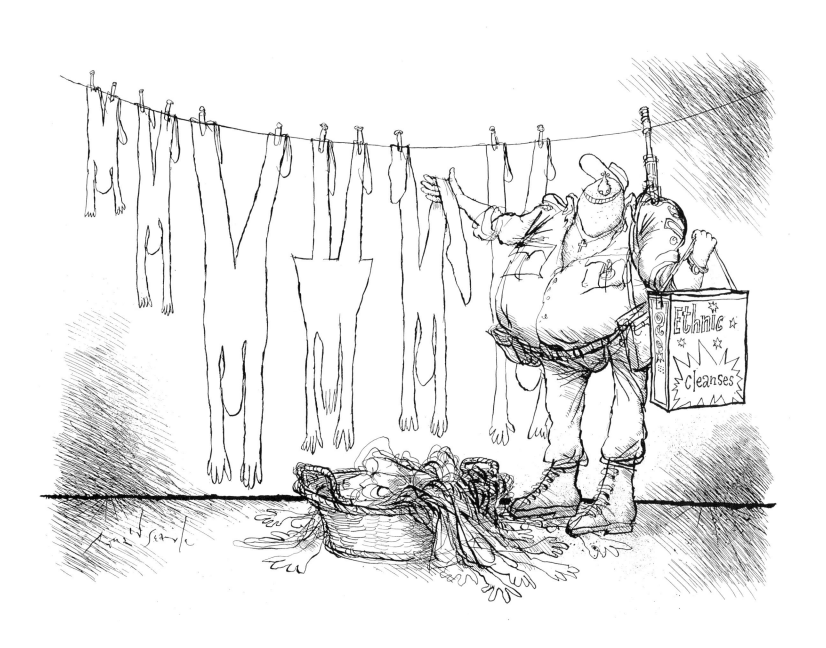

The big wash

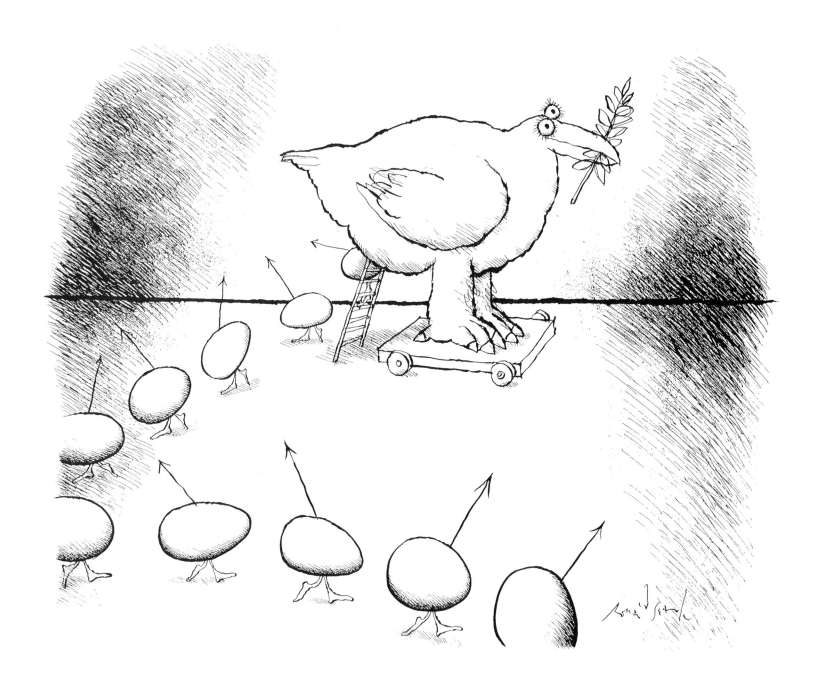

Peace force

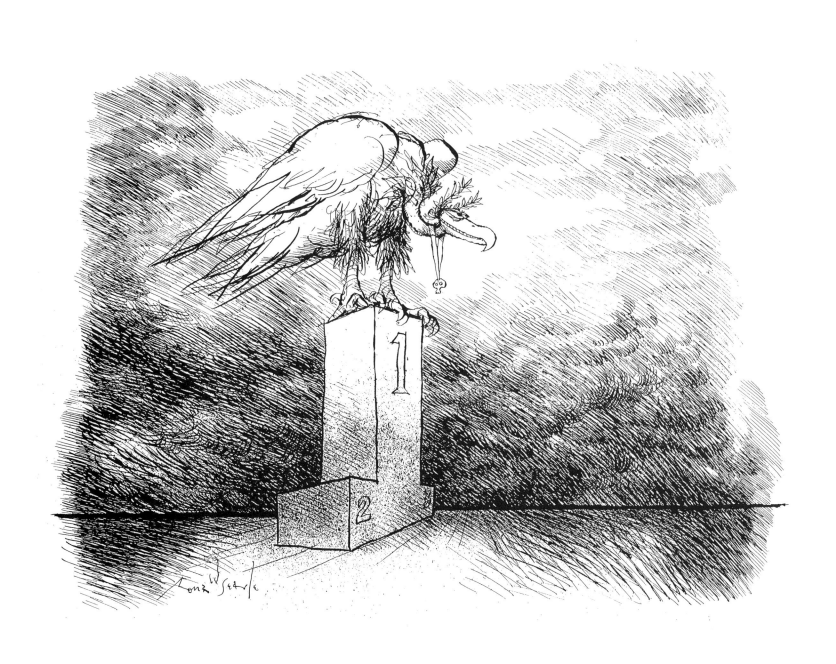

The winner!

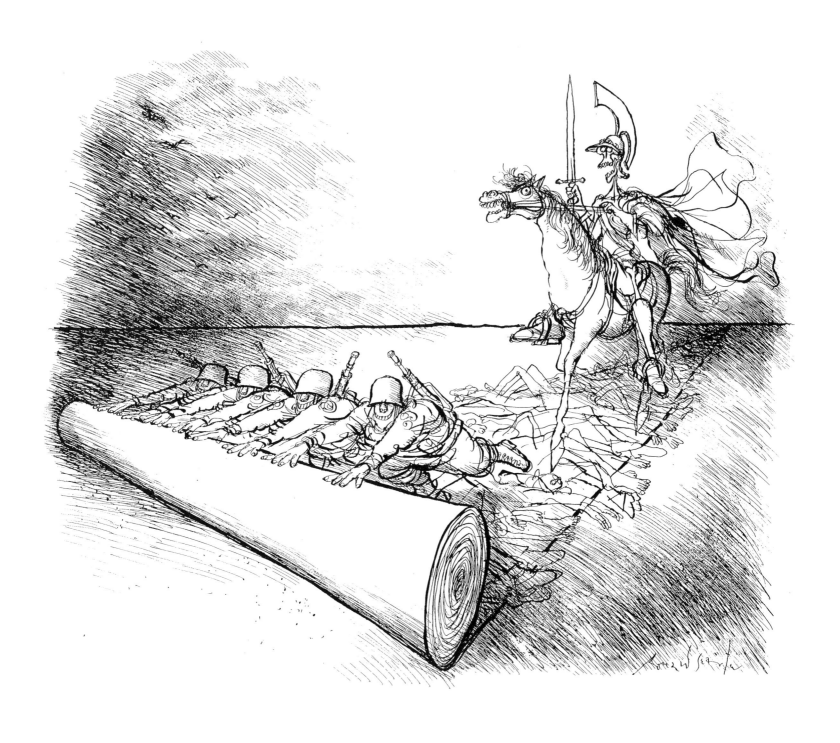

Red carpet

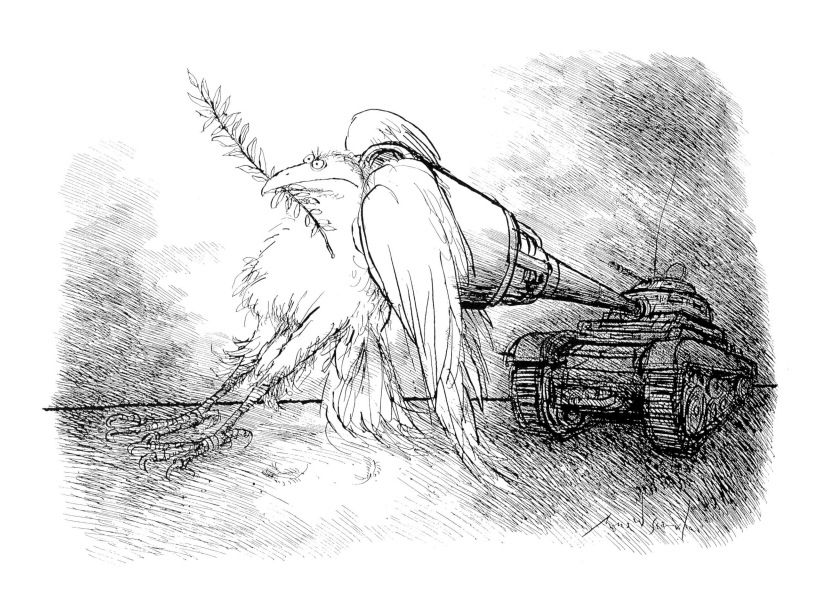

Irresistible force meets immovable object

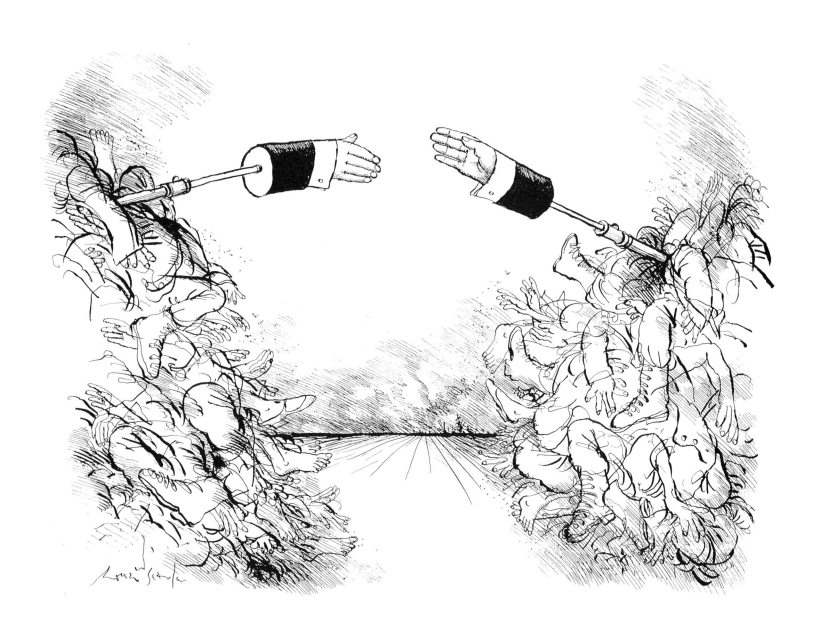

For the good of the people

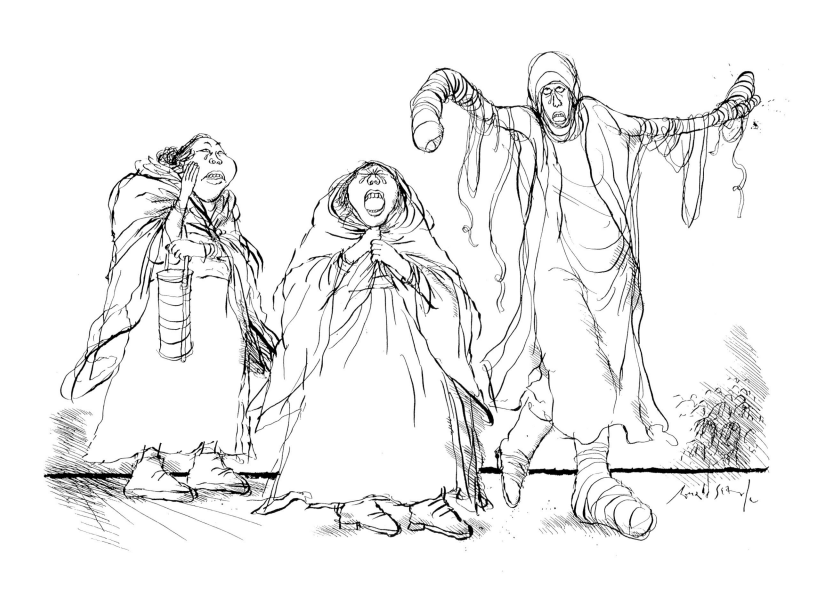

In fashion

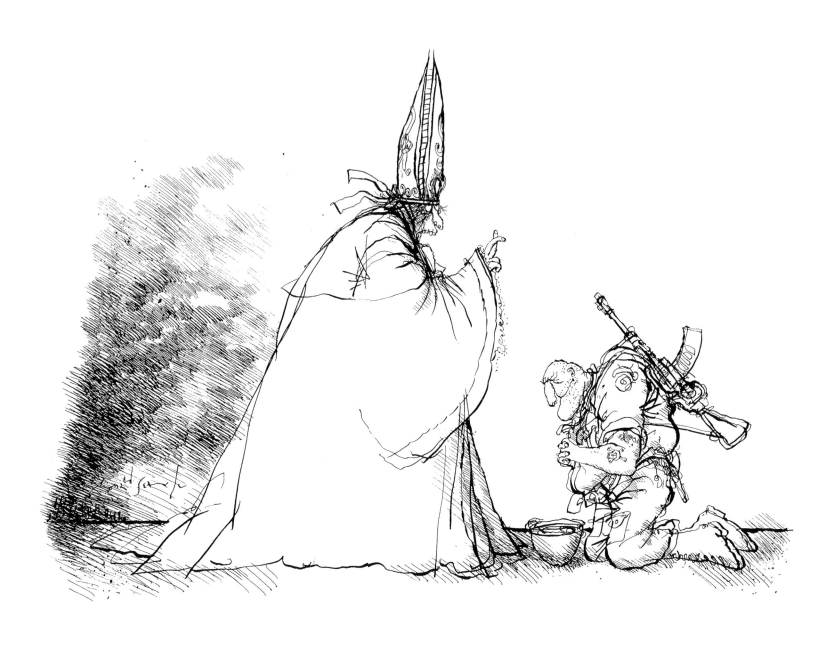

My God . . .

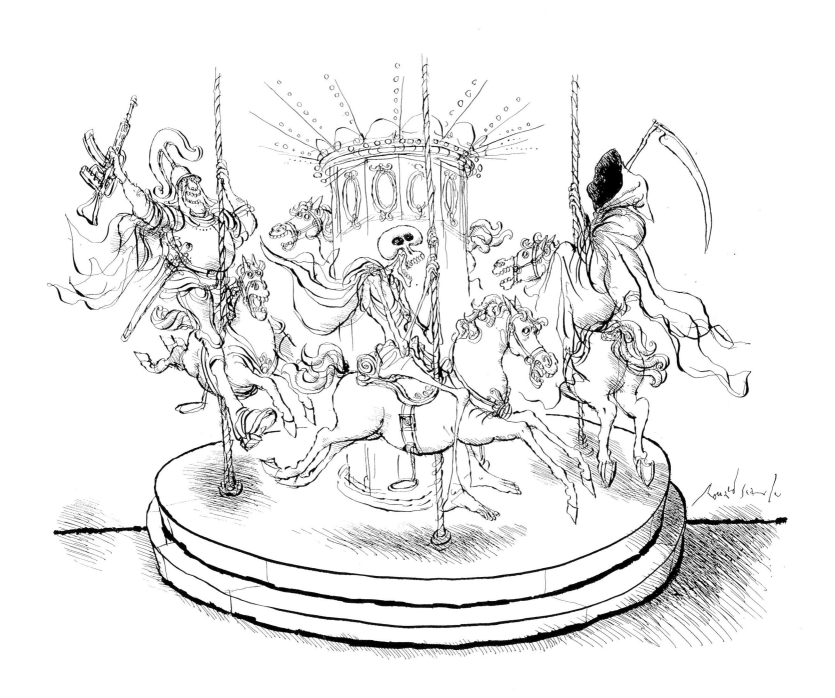

Carrousel

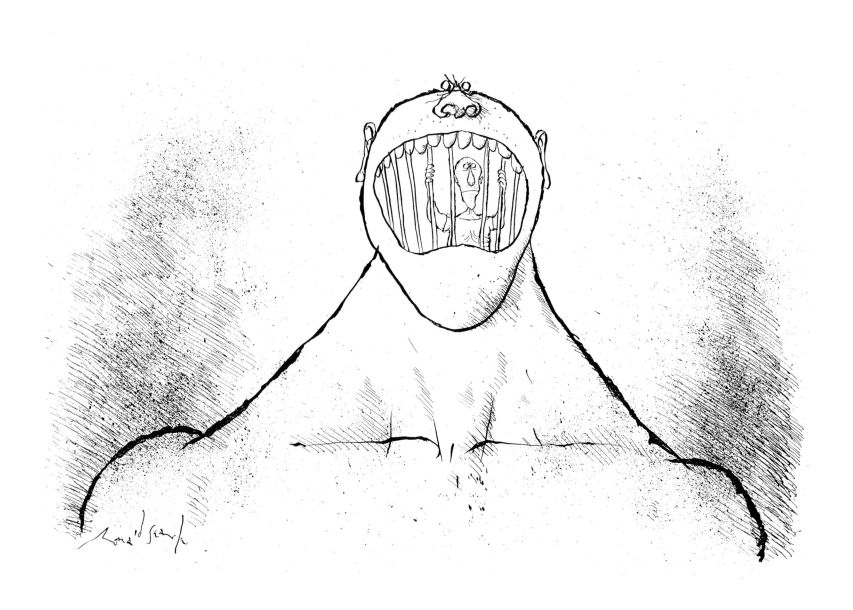

Tête-à-tête

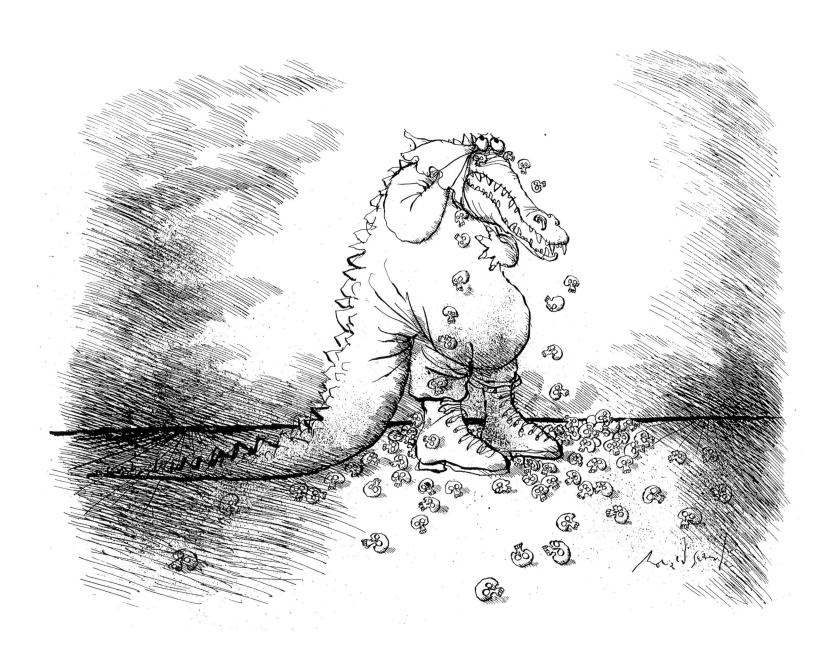

Crocodile tears

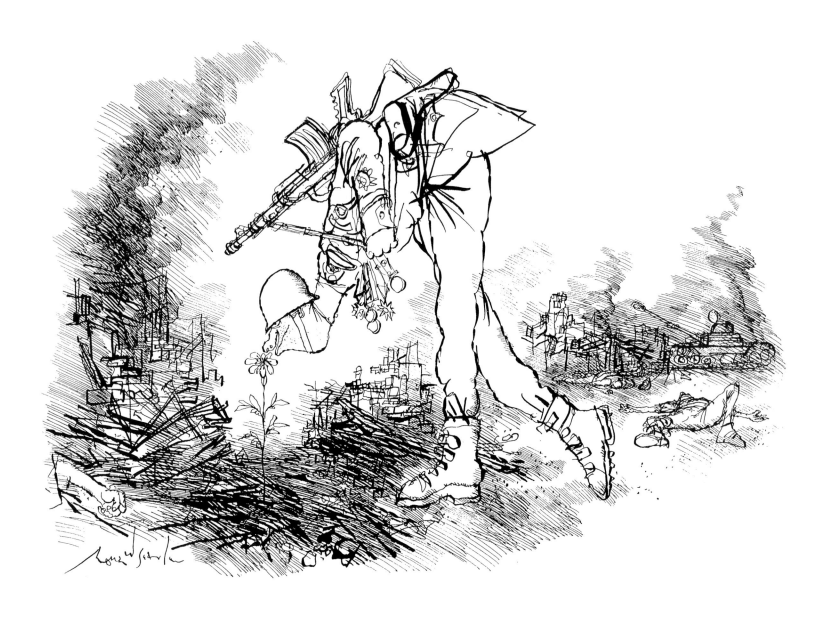

The sensitive one

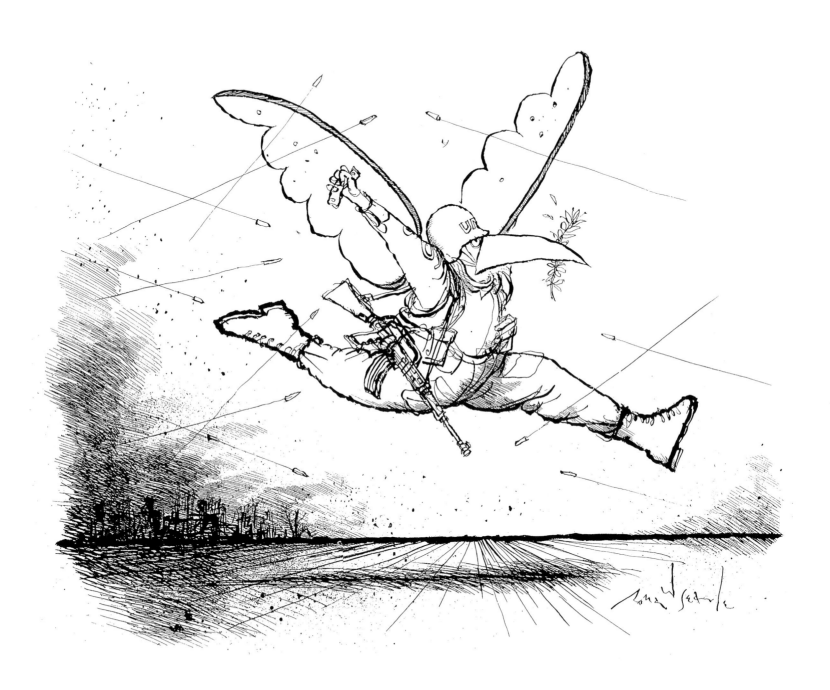

Pigeon of peace

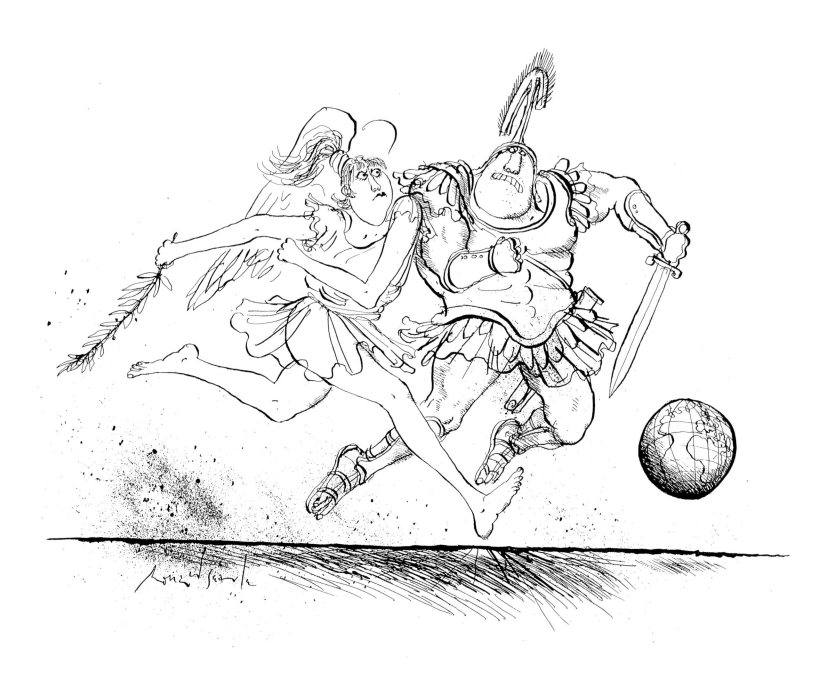

Match without end

SOME ANGELS

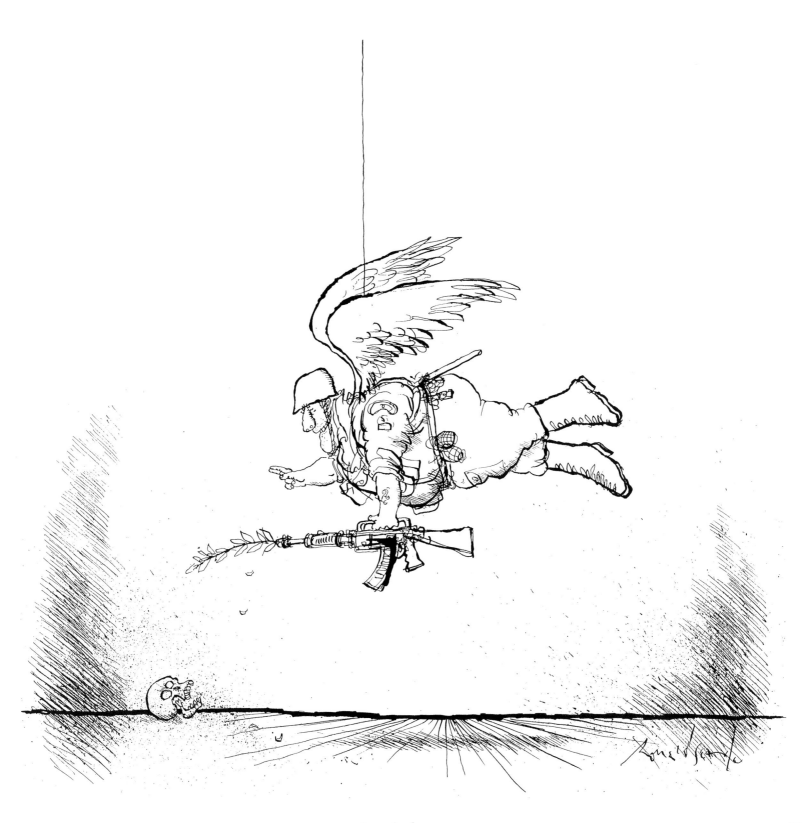

Angel of peace

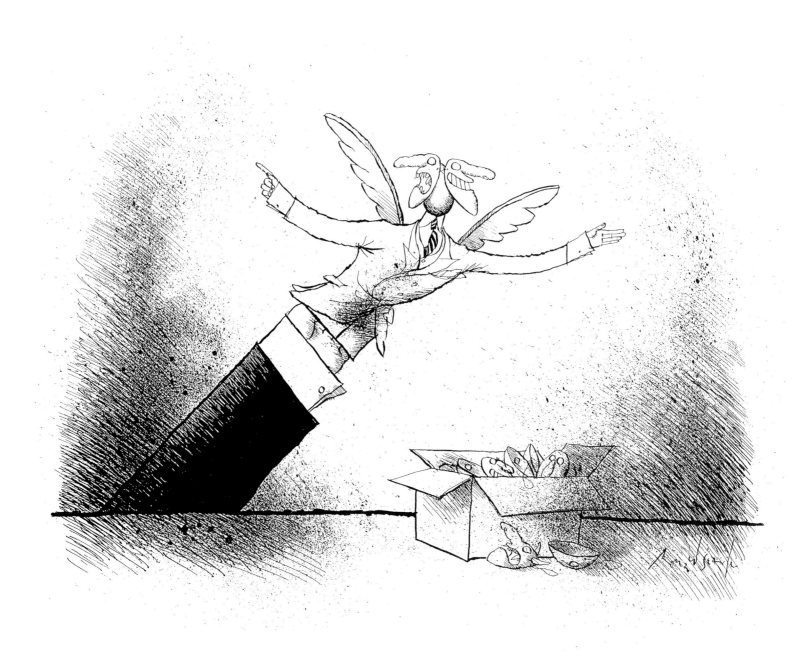

Angel of diplomacy

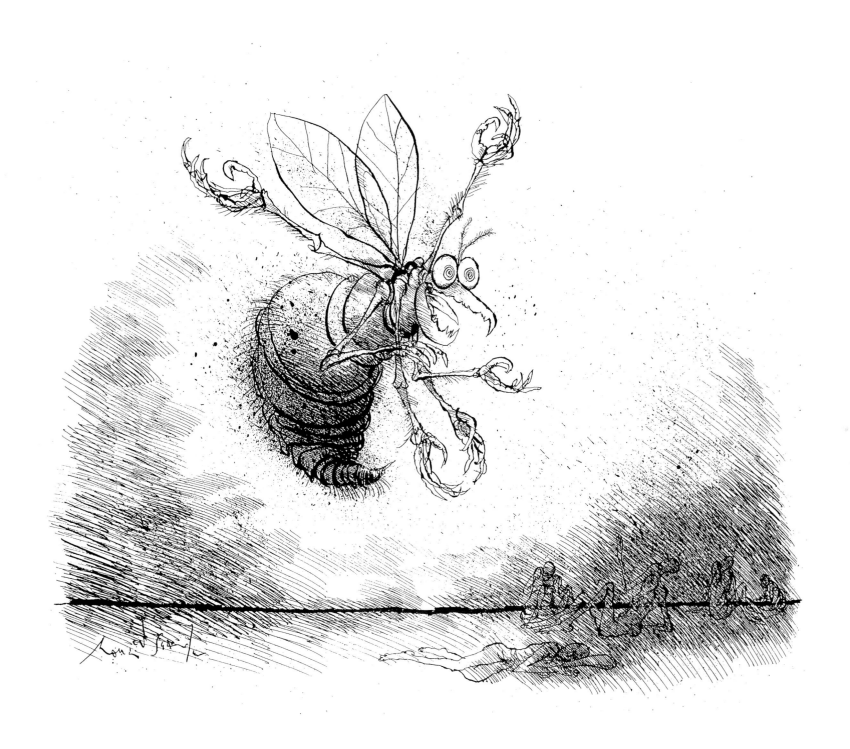

Angel of the third world

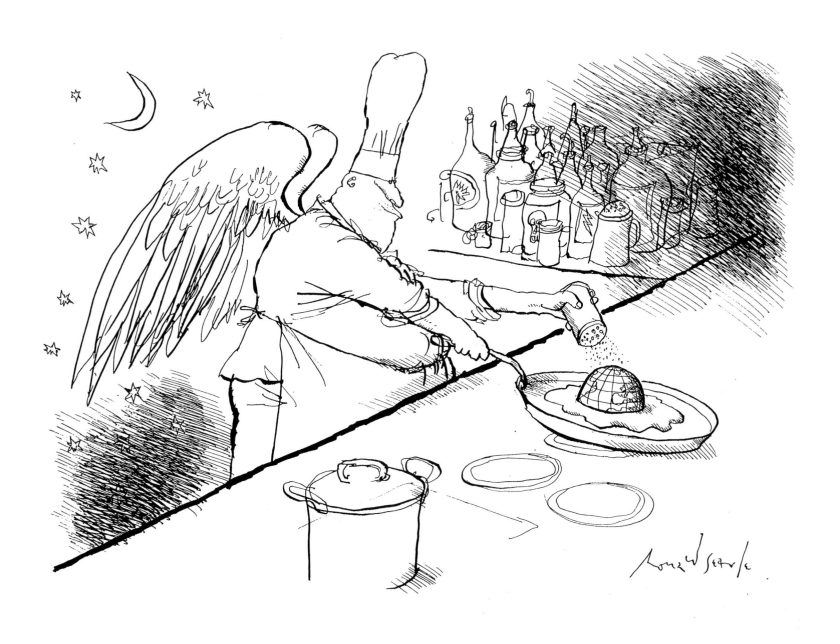

Angel of destiny

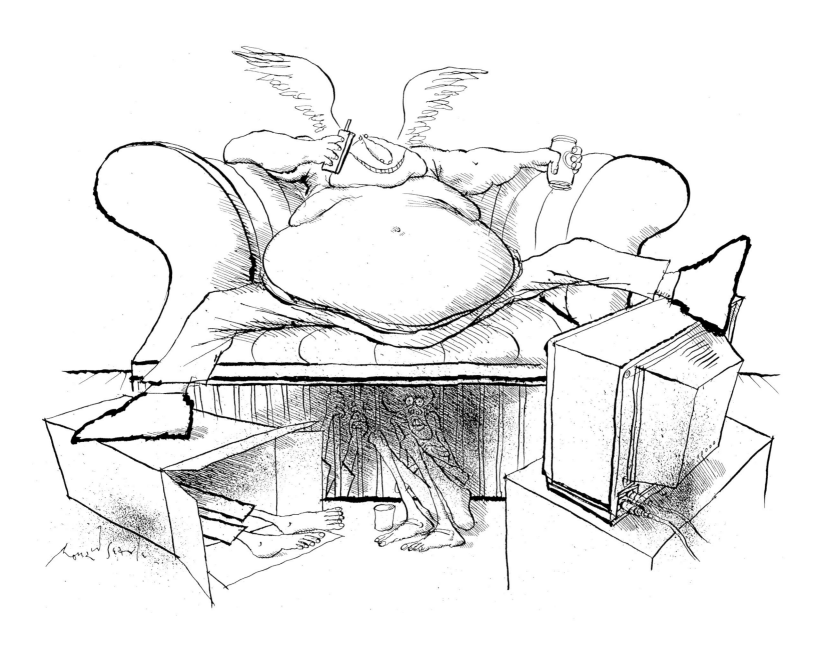

Angel of indifference

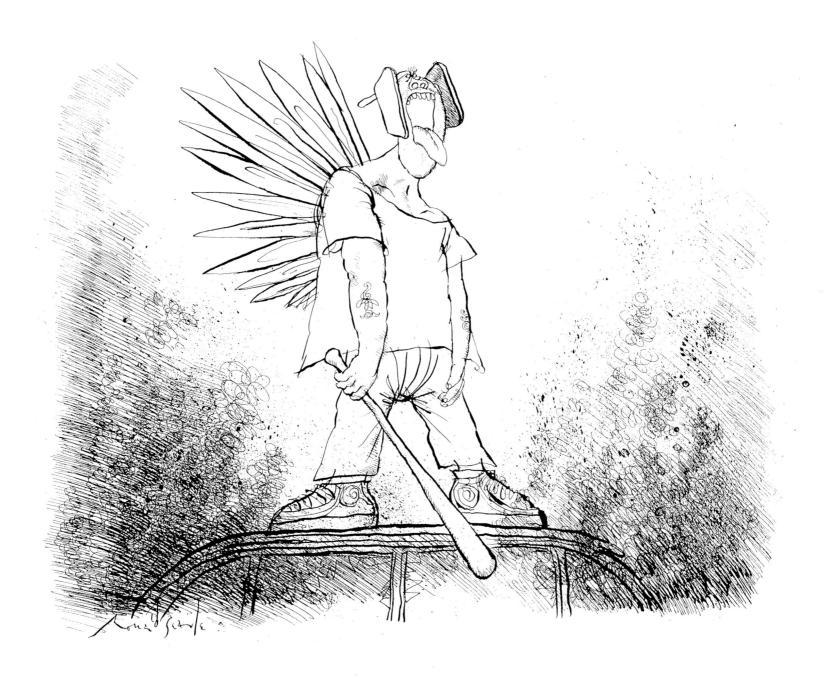

Angel of ignorance

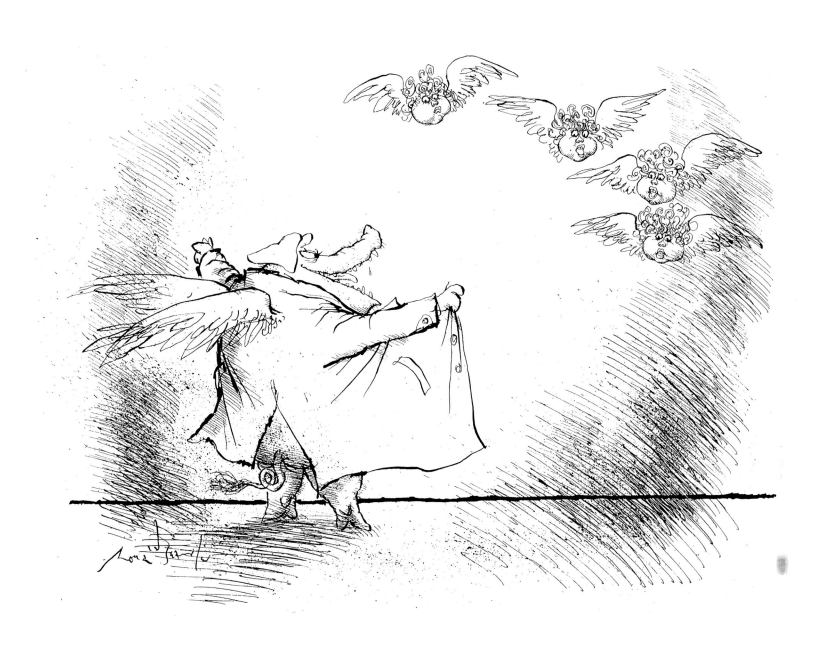

Angel of pedophilia

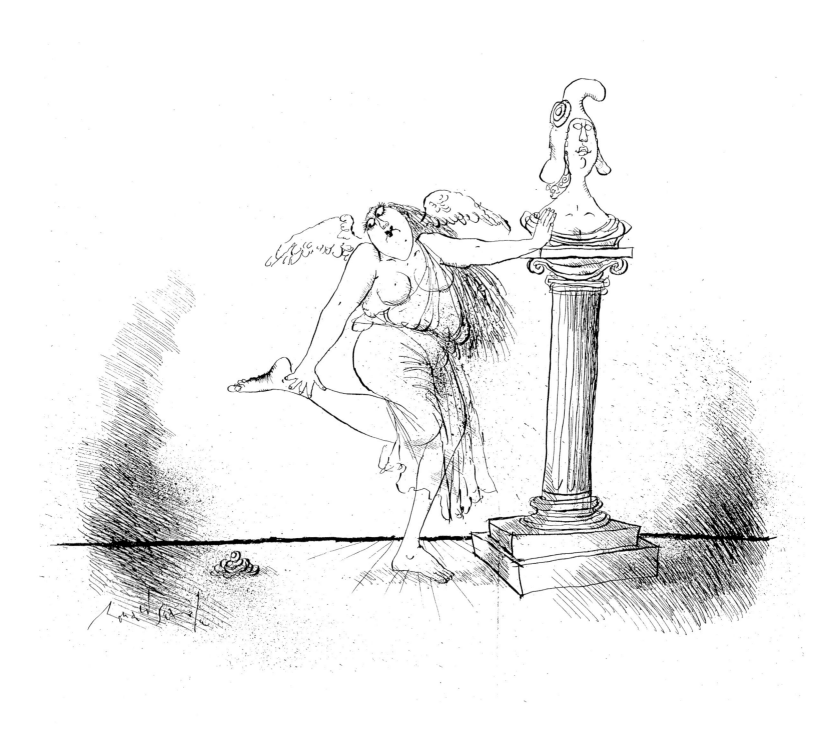

Angel of politics

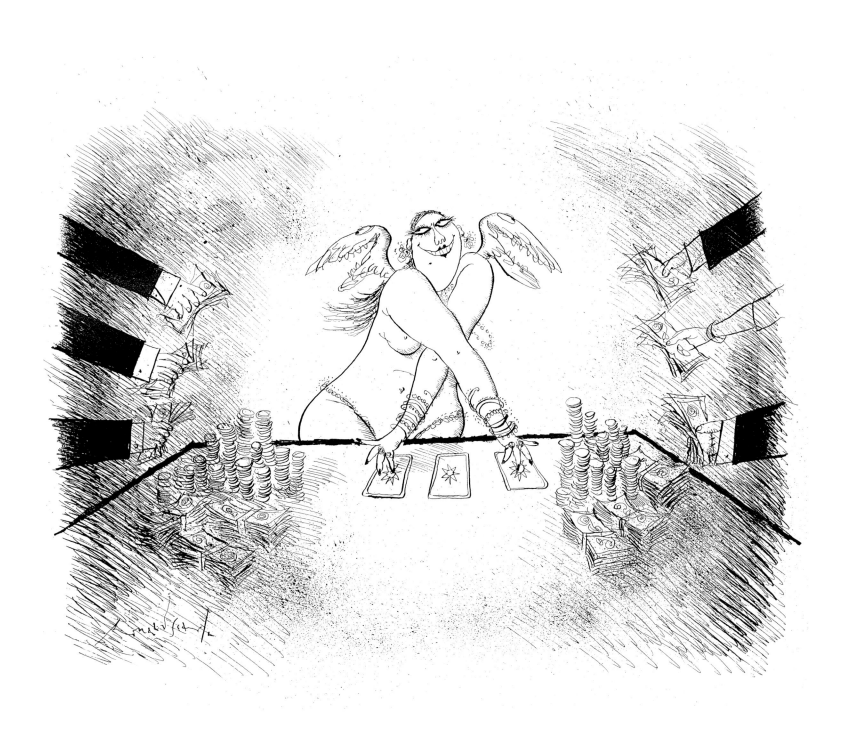

Angel of the stock exchange

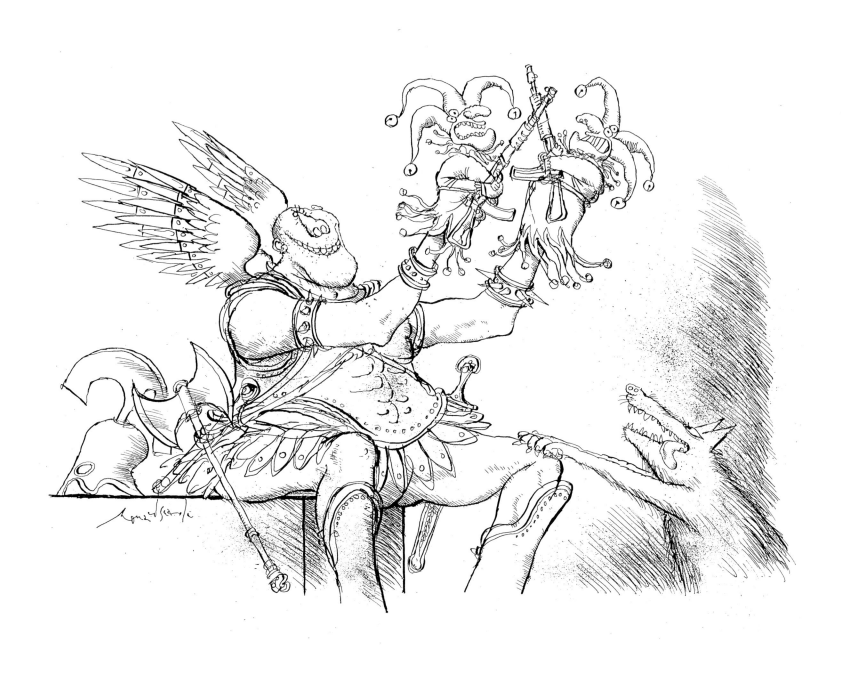

Angel of minor conflicts

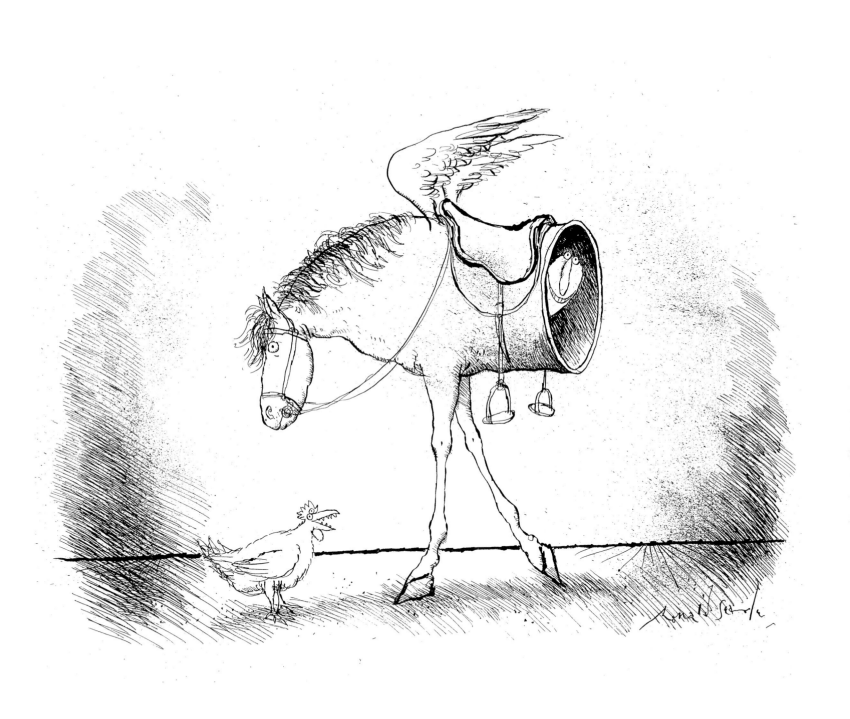

Angel of Munchausen syndrome

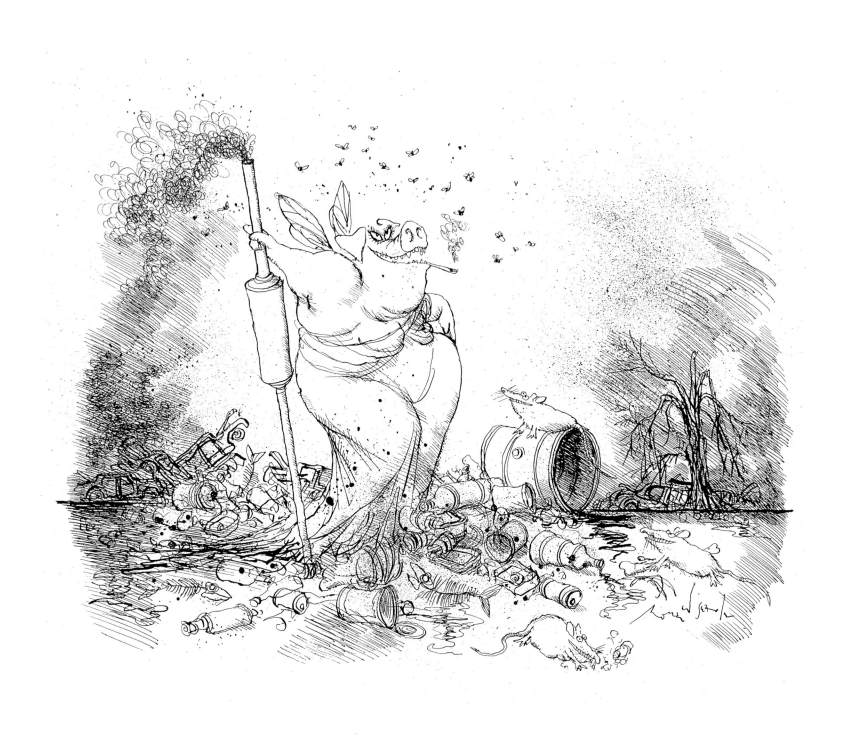

Angel of pollution

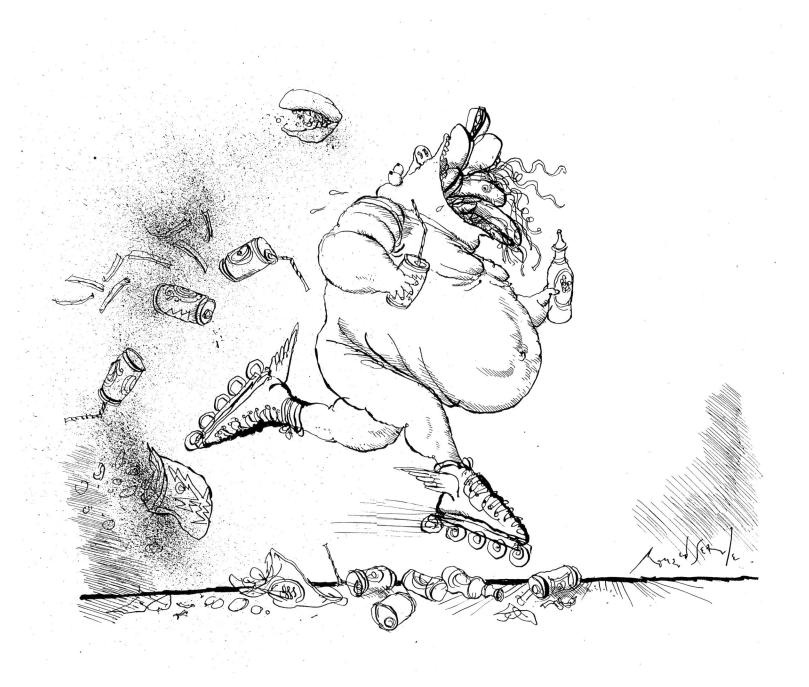

Angel of fast food

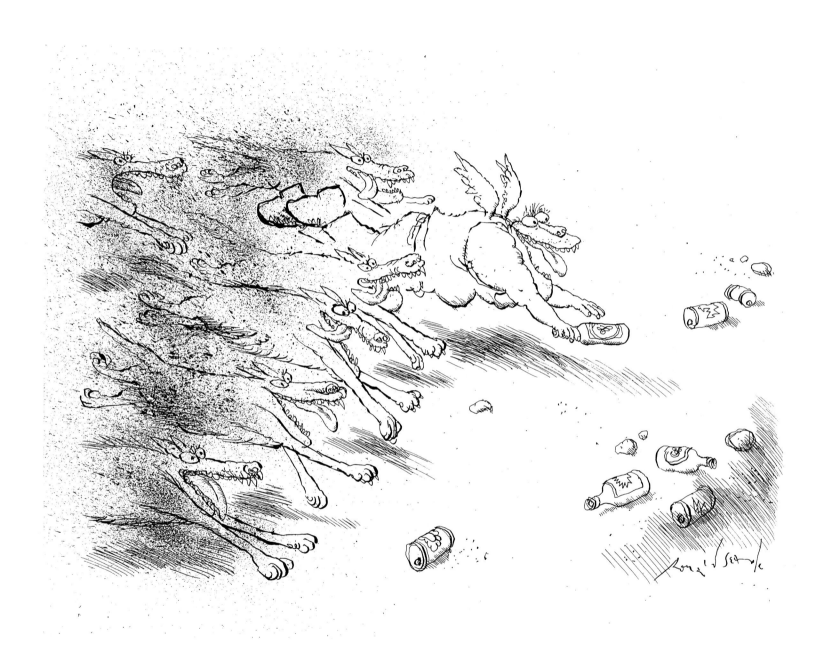

Angel of the vandals

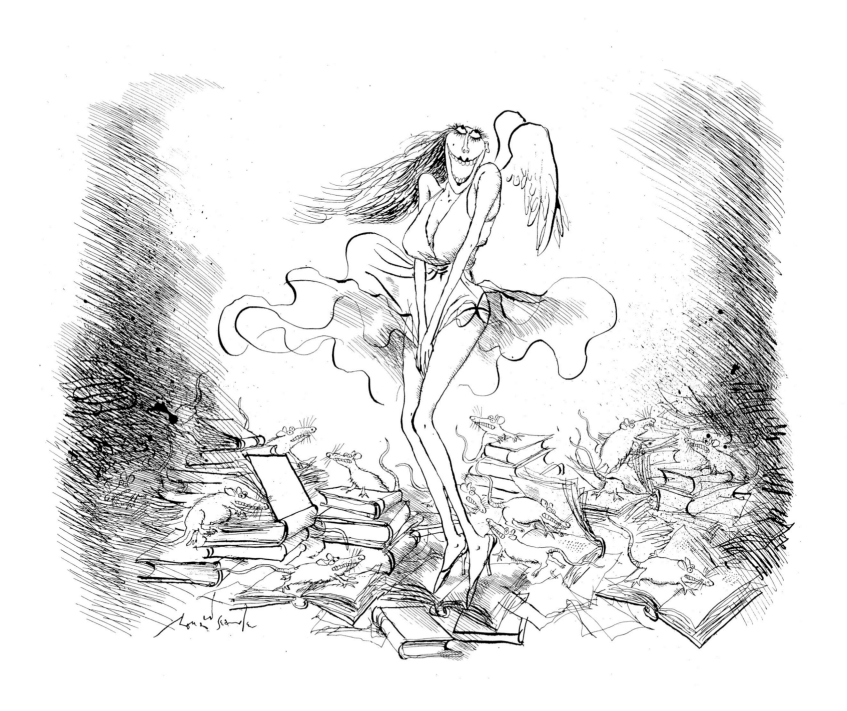

Angel of plagiarism

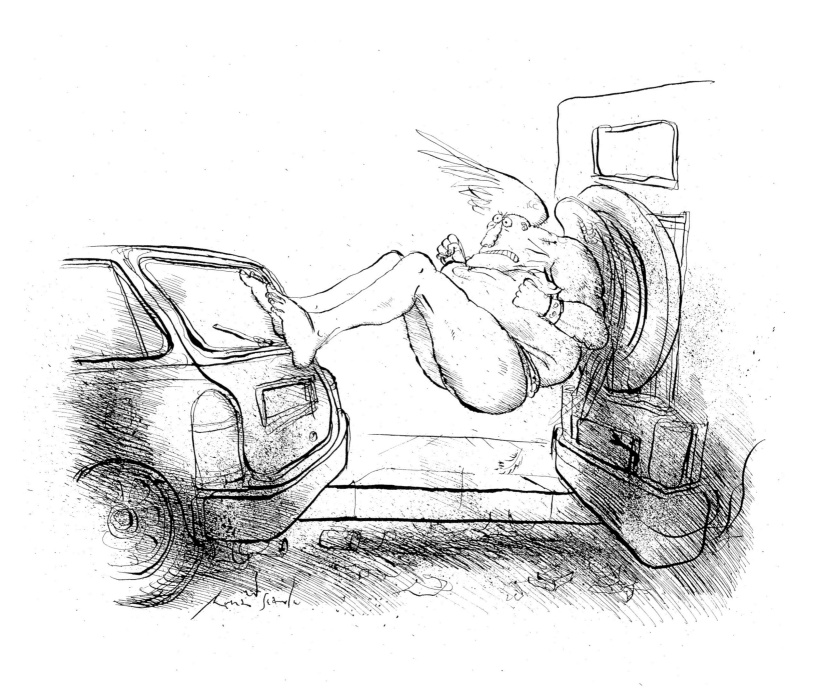

Angel of parking

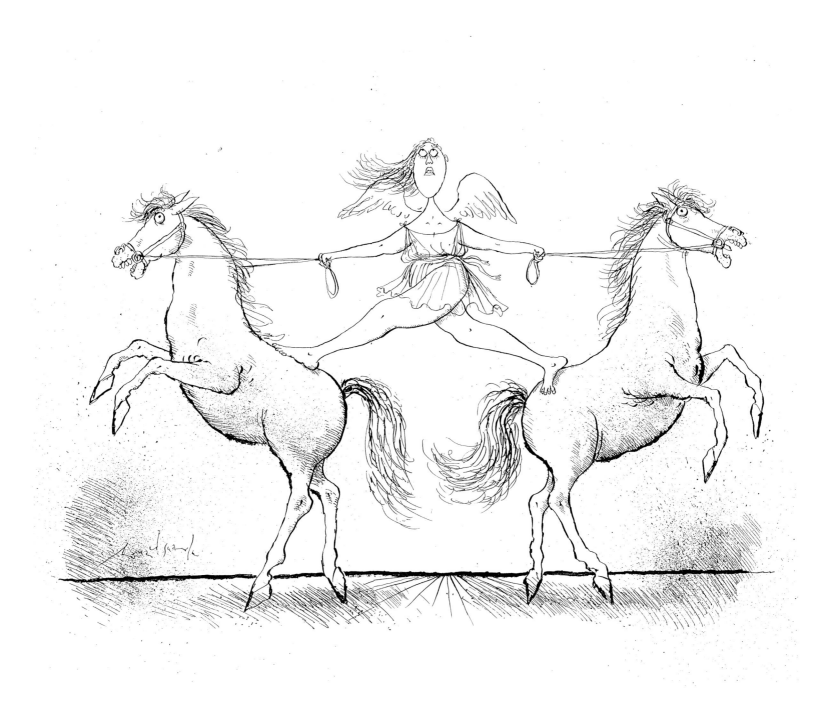

Angel of indecision

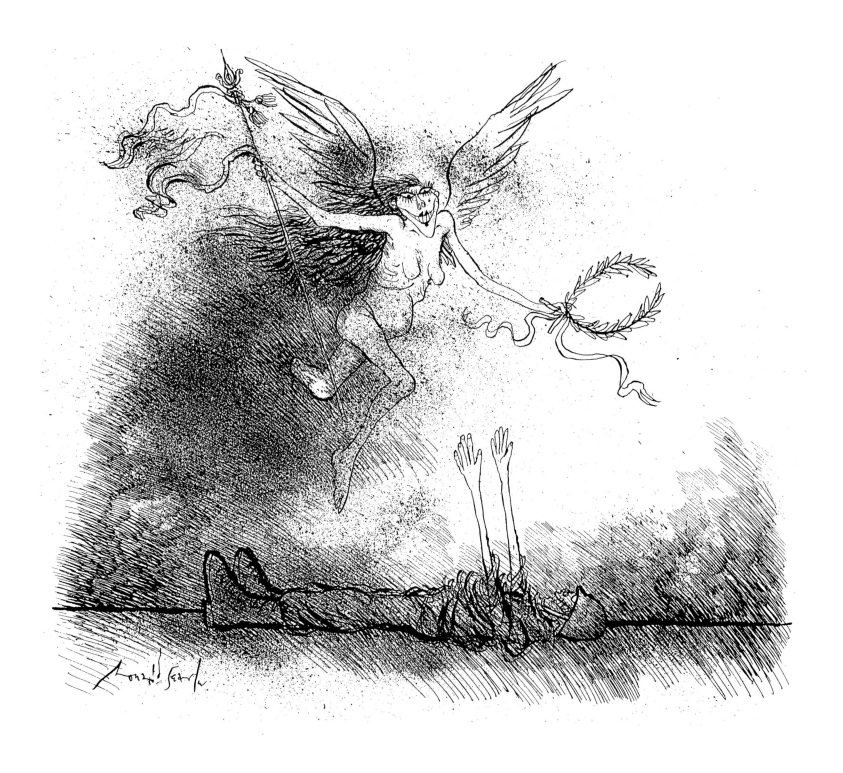

Angel of war

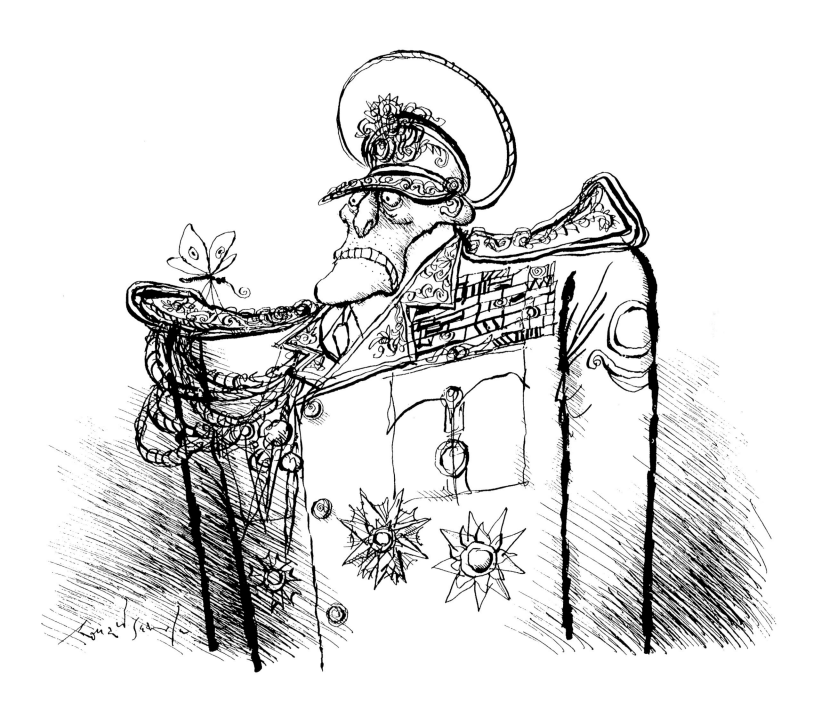

High treason

EPILOGUE

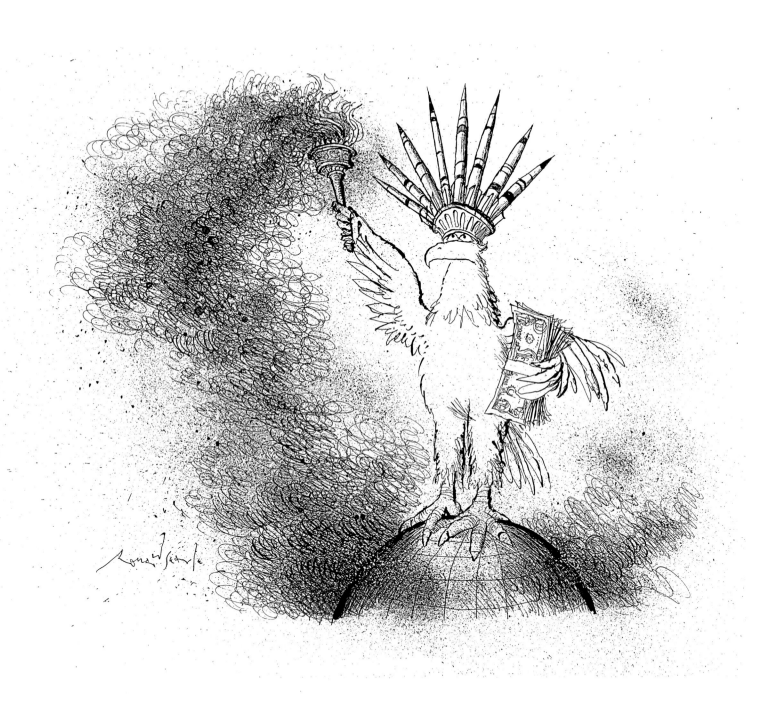

Liberty

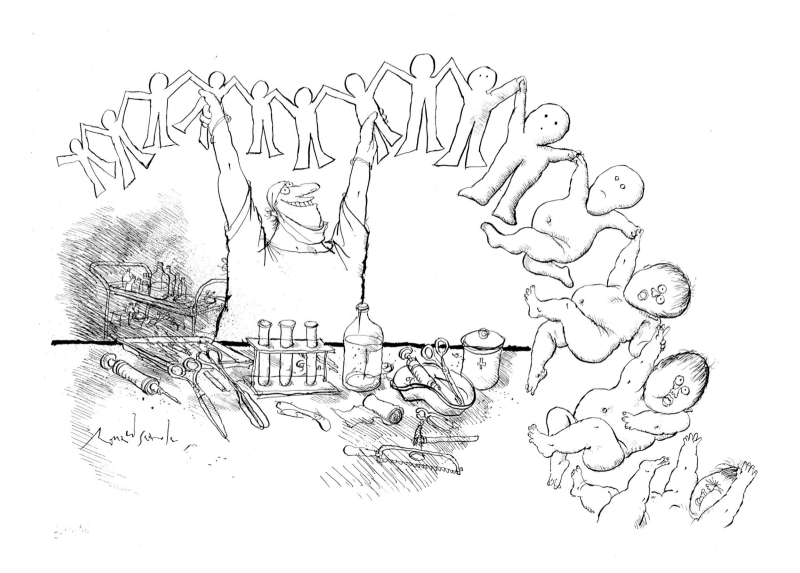

Evolution

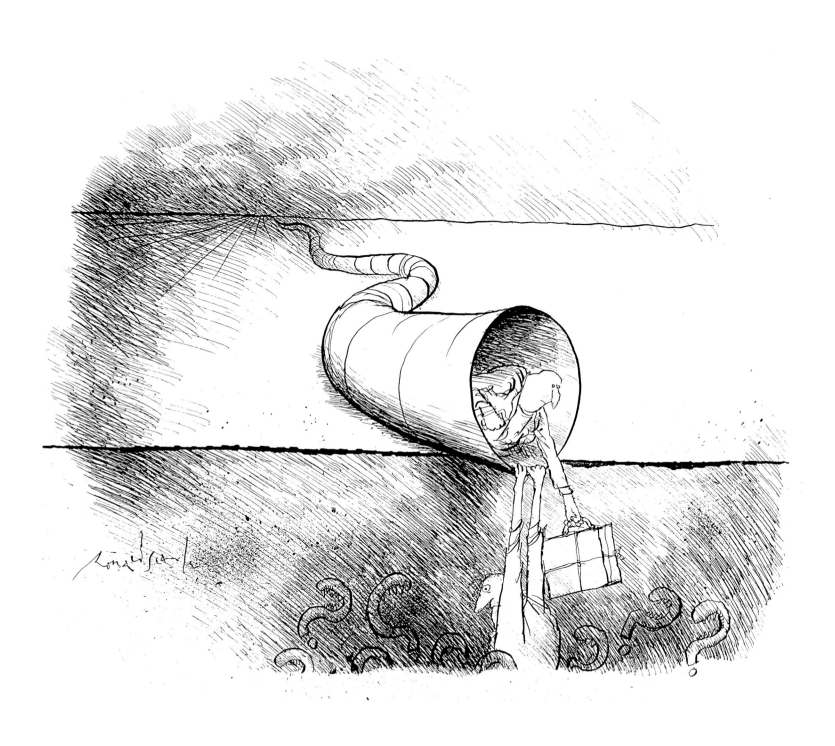

Clandestine immigration

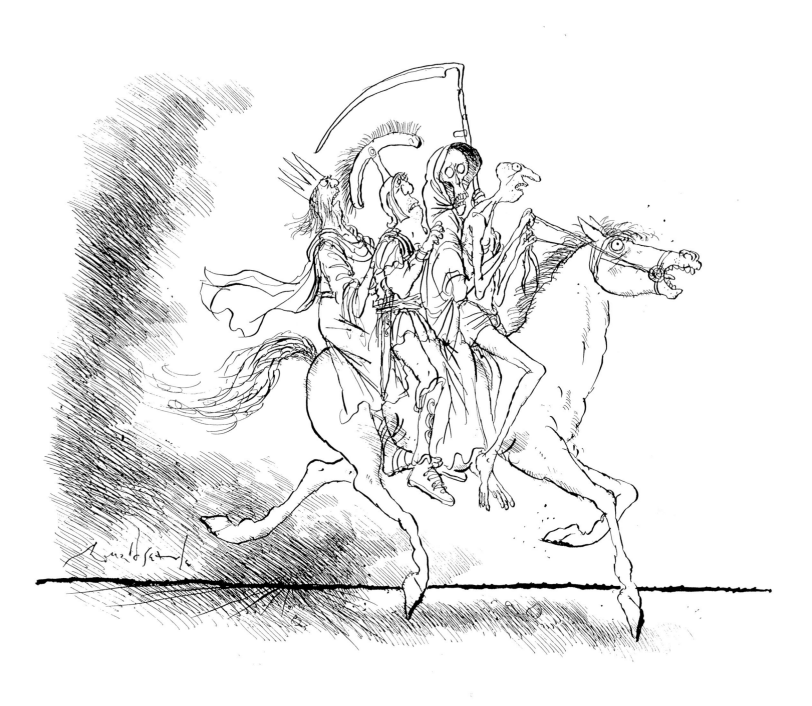

Recession

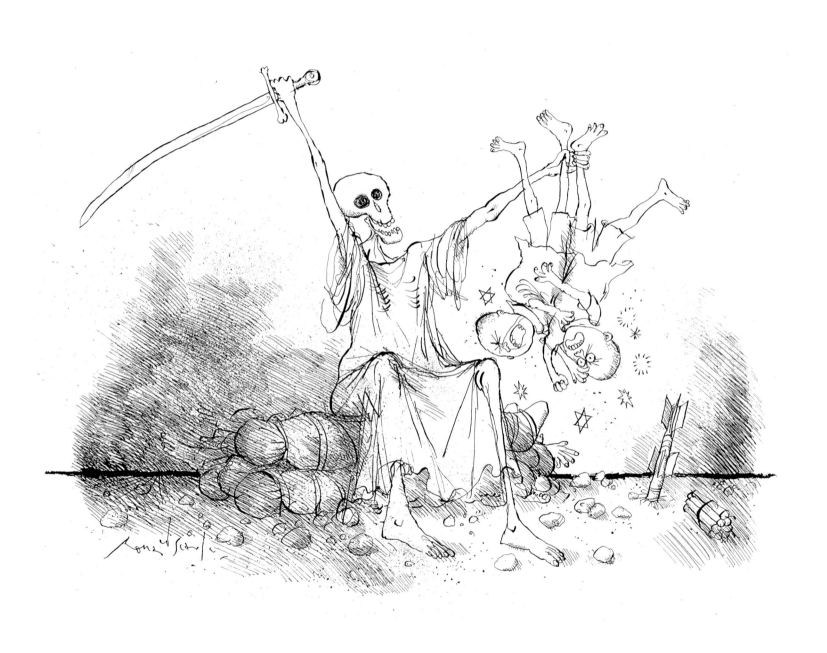

Middle East: The Judgment of Solomon